Praise for
Photo Organizing Made Easy

"Organizing a life's worth of photo memories is a daunting process for most of us. That's probably why we have piles of old photos buried in drawers and a zillion unorganized digital images on our camera rolls. Now in her straightforward, no-nonsense way, Cathi Nelson cuts through the clutter to make the task not only manageable but enjoyable. If you want to get your photos together so you can preserve, enjoy and share a lifetime of memories, *Photo Organizing Made Easy* is just what you need."

Tory Johnson
#1 New York Times *Best-selling Author*

"This is a rarity: an inspiring how-to book! Yes, it's possible, you can make something timeless and beautiful out of that mess you've been avoiding. Sharing and preserving family photographs is an act that requires a big heart—and so does writing a book about it. Fortunately, Cathi Nelson has one that's up to the task. Not only can you become a hero for future generations but you could have the time of your life doing it. This could be one of the most satisfying things you ever do. Who would have thought it? Well, Cathi Nelson. Great book."

Nick Kelsh
Award-Winning Photographer and Author,
How to Photograph Your Life

"No organizing project is more daunting than photographs, and no one is better equipped to walk you through the process than Cathi Nelson! This

book is warm, systematic, and insightful. You'll conquer years' worth of photos across multiple mediums, while honoring the emotions that go along with unearthing and preserving priceless memories."

Julie Morgenstern
New York Times *Best-selling Author,*
Consultant and Speaker

"This is a not simply a book; it's a pragmatic guide. And it's intended for anyone who wants to preserve their memories for future generations. Whether you want to organize your analog photos, or learn how to create a backup system for your digital photos, *Photo Organizing Made Easy* offers you step-by-step guidance as well as the insights of a passionate teacher who is well-versed in memory preservation."

Rachel LaCour Niesen
Founder, Save Family Photos and weGather

"Cathi 'gets' it! She seamlessly weaves the emotions we feel about photographs and their stories with a practical step-by-step guide to finally getting our family photographs organized, preserved, and enjoyed."

Karen Herman
Owner, Photos Organized Forever

"Cathi Nelson's book, *Photo Organizing Made Easy* is a must-read for anyone who is struggling to sort and organize decades of family photos and memories. Being a pioneer in the photo organizing industry, Cathi's knowledge and expertise, which she shares in the book, will help you take control of years of photo disorganization and give you a step-by-step process to bring your family memories back into your life so you can share them with future generations. It's an easy-to-read guide to motivate you to take steps now that will provide immediate rewards; happy, organized, and easy-to-access memories!"

Deborah J. Cabral
Certified Professional Organizer, and TV Host,
Organization Motivation! and Organized in 60 Seconds

"Cathi Nelson's book *Photo Organizing Made Easy* is more than a how-to. A visionary and storyteller, Nelson identifies the bigger picture of what is preserved and convinces readers of the happiness awaiting those who invest in this practice."

Jane Pollak
Author, Soul Proprietor: 101 Lessons from a Lifestyle Entrepreneur

"This book is a gold mine of information and practical techniques needed to safely preserve and organize your lifetime of memories. Straight from the founder of the global photo organizing movement, it covers everything from sorting printed photos to scanning, video transfer, archiving, backup, and how to manage your growing collection of born-digital memories. But most importantly, it inspires and motivates with a collection of real-world stories that will move you to action."

Ed O'Boyle
Founder and CEO, FotoBridge

"Cathi Nelson has hit the mark with this book! So many people are overwhelmed by their photo mess that they don't even know where to start. What this book does is not only tell you where to start, but most importantly, gives you the how—a proven method widely used by professional photo organizers that you can use to reconnect with your photos and the precious memories that are buried in boxes and hard drives. Cathi understands the emotional connection we have to our photos, and helps the reader navigate that as well. This is the only guide you will need to get your photos back into your life, and leave a wonderful legacy for your family."

Kathy Stone
Owner, Calgary Photo Solutions

"I remember my first conversation with Cathi back in 2010 like it was yesterday. I was sitting on my couch trying to cram in some phone calls while my oldest was in preschool and my youngest was napping. I was so excited to talk to someone as passionate about photos and their

power as I was. Fast forward seven years and it's easy to see that passion has remained. Cathi perfectly articulates the importance and the steps it takes to get your photo collection in order. There's no denying it can be overwhelming but if you follow Cathi's direction, you will have your collection in order and be looking for new projects and helping your friends too!"

Rachel Jenkins
Owner, ScrapMyPix, LLC

"Cathi Nelson's book provides an inspirational mix of the how-to's of organizing your family's photo collection along with inspirational ideas to help you understand the magnitude and treasure of taking on such an effort. It's a guide and heartwarming book all wrapped up in one book!"

Bonnie Hillman Shay
Owner, Mariposa Creative Solutions

"As an industry partner with the Association of Personal Photo Organizers (APPO) for many years, we've learned to expect nothing but enthusiasm and positive energy from Cathi. She has been passionate about preserving and sharing photos from our first conversation. We look forward to her next chapter and that of APPO."

Angela Blauvelt
GM, Archival Methods

"I hired Cathi to consolidate a lifetime of pictures!!' My husband and I had been married thirty-five years at the time and had two children. I sent Cathi about 3,000 pictures. She was in constant communications with me about the gift I wanted to give my boys (a Zip drive of their lives) and she consolidated my family pictures in a movie fashion. It was wonderful! I never could have done it. It was worth every dime!!"

Caren C.
Former client of Cathi Nelson

PHOTO ORGANIZING MADE EASY

PHOTO ORGANIZING MADE EASY

Going from Overwhelmed to Overjoyed

Cathi Nelson

PUBLISH
YOUR
PURPOSE
PRESS™

Publish Your Purpose Press
141 Weston Street, #155
Hartford, CT, 06141

The opinions expressed by the Author are not necessarily those held by Publish Your Purpose Press.

Ordering Information: Quantity sales and special discounts are available on quantity purchases by corporations, associations, and others. For details, contact the publisher at the address above.

Edited by: Katie Petito, Karen Ang
Cover design by: Lisa Knight
Headshot by: Patty Swanson
Typeset by: Medlar Publishing Solutions Pvt Ltd., India
Printed in the United States of America.

ISBN: 978-1-946384-22-5 (print)
ISBN: 978-1-946384-23-2 (ebook)
Library of Congress Control Number: 2017959510

First edition, December 2017, ii.

Publish Your Purpose Press works with authors, and aspiring authors, who have a story to tell and a brand to build. Do you have a book idea you would like us to consider publishing? Please visit PublishYourPurposePress.com for more information.

Dedication

To **Miriam** Therese Winter, beloved professor, theologian, singer, songwriter, author and, most importantly, friend who inspired me to create an organization dedicated to helping people uncover the stories hidden in their photo collections.

To **Lisa** Kurtz, the COO at APPO, whose support, wisdom, integrity, pursuit of excellence, and friendship makes all the difference, day in and day out.

To The **Photo Organizers** and members of APPO who care deeply for the clients they serve and lead the way in this new and growing profession.

And last but not least, to my **husband Larry**, who—in the midst of reading hundreds of high school history papers—willingly stopped to listen, edit, and read the many rough drafts of this book.

"After nourishment, shelter and companionship,
stories are the things we need most in the world."
—Phillip Pullman

Contents

Introduction

In the spring of 2017, I was the keynote speaker at a conference of the Association of Professional Declutterers and Organisers in London. Also present was James Wallman, author of *Stuffocation: Memories Live Longer Than Things*, who said, "Experiences lead to stories, which lead to connections, which lead to relationships, which lead to happiness."[1] As the founder of the Association of Personal Photo Organizers, I would put it this way: We photograph our experiences, which

> We take photos to tell the stories of our lives.

tell a story, which leads to connection, which leads to relationships, which leads to happiness. Essentially, we take photos to tell the stories of our lives.

The purpose of this book is to encourage and empower you to take the time to find and sort through the thousands of photos you likely have stored in shoeboxes under your bed or in fading photo albums, as well as conquer the thousands of images on your phone

or lost on your computer. The reason is simple—I know without question—that you will never regret undertaking this project, because buried in those photos are moments and memories that will bring you joy along with feelings of nostalgia as you reflect on the passage of time.

The photo organizers, whose advice is shared throughout this book, and I have worked with thousands of clients just like you. We know that in those boxes are memories of loved ones who have passed away, vacations, the first day of school photos, celebrations of babies born, weddings, and birthdays. Also, mixed in are sunsets and sunrises, fall foliage and spring flowers, beloved pets, and friends—a tapestry of your life. My goal is to help simplify this process for you, so you can once again enjoy your photos and go from overwhelmed to overjoyed.

But first, let me share how I came to be a personal photo organizer and start an entirely new industry. "We are a people of stories." That simple statement was uttered by MT Winter, a professor at Hartford Seminary, in the fall of 2007. I was sitting in her class and struggling with how to express what I did for a living. I had devoted over fifteen years to teaching people how to create scrapbook photo albums, and it had been a trendy hobby. In fact, in 2004, the headline on *Business Wire* said, "Annual Sales for Scrapbook Industry Reach $2.55 Billion." However, a change was coming, and it was coming quickly. I could sense it, but I couldn't put my finger on it. In fact, another headline, just nine years later, summed up what I had intuited: "Scrapbooking is Dead." Little did anyone realize that not only was scrapbooking dying, but the entire photo industry was undergoing an upheaval. Kodak, one of the world's most beloved brands and a household staple, no longer exists.

In his book, *The Power of Habit: Why We Do What We Do in Life and Business*, Charles Duhigg[2] describes the motivations

behind purchases and the reason purchasing decisions change. His explanation is relevant to why the photo industry has declined so precipitously over the last several years. All habits start with a cue, continue with an action, and then end with a reward. For printing photos and placing them in albums, the cue was a roll of film and a stack of 4×6 prints (preferably a large stack of double prints); the action was printing and then purchasing and completing a photo album. The reward was the finished book. With digital cameras, the traditional cue is missing. Prints, something one can hold in one's hand, are no longer a consequence of pressing the shutter, and the average person quickly forgets about an array of files stored somewhere on a hard disk or memory card. Out of sight is truly out of mind.

While scrapbooking was a popular hobby, I have always believed there was something more going on when people print photos and place them in albums. In fact, every year I would take over 100 women on a scrapbooking retreat, and I would ask myself what is actually happening here. What is drawing these women to take the time away from busy lives to work on their family photo albums? I felt the same way when I once had 1,800 women at the Connecticut Convention Center sitting at tables, working on their photo albums for twelve hours. We called it a "crop 'til you drop" event. I would always walk around and think that this isn't just about cutting photos into creative shapes. This is about something much bigger than that; this is about sharing and community building. That is why MT Winter's simple declaration clarified for me what I knew all along. We take photos to tell our stories, and that is what people care most about. Those words changed the direction of my life and gave me a vision for the future. I know that if your photos are unorganized, there is no way you can actually enjoy them and share a story.

As I have looked back on the trajectory of my career, from working in advertising and marketing to scrapbooking to founding the Association of Personal Photo Organizers (APPO), my passion for creating photo narratives should not have come as a surprise to me since I have always been a lover of stories. One of my earliest memories is sitting on the front steps of my neighbor's house at around age three or four and being read to. Stories transported me to a different place, and the world opened before me.

This book is written in chapters that reflect the most common issues people have with organizing their photo collections. Each section can be read as a standalone chapter, and, at the end of each chapter, I list Cathi's Pics; these are the companies, products, services, and resources I recommend. On my website, www.CathiNelson.com, you will find links to handouts you can download and other information you will need. I also interviewed personal photo organizers and other professionals, whose stories are included at the end of the book. Reading those will give you the inspiration you need to keep moving forward.

Each section can be read as a standalone chapter, and at the end of each chapter I list Cathi's Pics; these are the companies, products, services, and resources I recommend.

Last of all, if you need help, you can find a photo organizer near you by going to www.appo.org and clicking on the "find an organizer" tab. Personal photo organizers are ready to assist you by offering guidance, training, and support. If this is a career that appeals to you, we also offer comprehensive training, professional certification, an annual conference, and a warm and welcoming community. We would love to welcome you to APPO.

Now it's time to get to work uncovering a treasure of memories and stories!

 ## CATHI'S PICS

Websites
Cathi Nelson
www.CathiNelson.com

Association of Personal Photo Organizers
www.appo.org

Photo Organizers Academy - Online Classes
www.photoorganizers.academy

Photo Safety Tips & Help
www.saveyourphotos.org

Social Media
Facebook
https://www.facebook.com/thephotoorganizers/
https://www.facebook.com/cathinelsonspeaks/

Pinterest
https://www.pinterest.com/photoorganizers/

Instagram
https://www.instagram.com/photoorganizers/

Forms
Download our simple-to-use checklists to make your organizing job easier. www.cathinelson.com.

01
Getting Started

The hardest part of any project is getting started. If you are like me, you can find all sorts of reasons and ways to distract yourself from the job at hand. This is especially true when trying to organize your lifetime of photos. First of all, you have to find the photos. Then, there are the unmistakable feelings of nostalgia that will wash over you. All of this is normal, and that is why we are here to help. You can follow these tips in the order they are written or pick the tips that are most manageable for you. Are you ready? Let's get started!

STEP 1

SET A GOAL

The first step to getting your photo life organized is picturing the end result. Just like any goal, you need to have a concrete vision

with a timeline for completion. Having an end goal and a deadline will help motivate you toward completion. Think ahead to when you have your entire photo and video collection organized and accessible. How would you like to share and enjoy these pictures? Do you want a family yearbook with highlights? Do you want a photo gallery on your wall with milestone events? Do you want online photo albums that other members of your family can access? What about a video slideshow to enjoy with some popcorn? Choose a few fun ways to celebrate and to share your photos!

Next, think about those with whom you are going to share your photos, and let them in on your plans. You are more likely to achieve your goal when you tell someone who can hold you accountable. You can do it!

STEP 2

HUNT AND GATHER

Let's get down to business. Remember the saying: "out of sight, out of mind"? Depending on the size of your photo collection, you may be working on hunting and gathering for a while. If everything is tucked away or hidden in closets and on computers, it will be easy to forget. You've made a commitment to organize your photos, so let's get them into an area where you can work on them.

If space is an issue, take a photo of the locations where your photos are stored so you can create a vision board of what you have found.

Designate a temporary workspace in your home that allows you to spread out what you have found. A large table in the corner of a room or a separate room is ideal and causes the least amount

of disruption. If you set yourself up on your dining room table, then you may have to pack it up again when you want to sit with the family for dinner! If space is an issue, take a photo of the locations where your photos are stored so you can create a vision board of what you have found.

Next, gather your memory collection into your workspace. Locate all photo albums, loose printed photos, memorabilia, kids' artwork, negatives, slides, undeveloped film, memory cards, family artifacts, and home movies (on VCR tapes, mini DVs, film, etc.). Visit cathi.nelson.com and download our easy to use inventory checklist and make a list of all the devices on which you have photos stored, such as your smartphone, computers, and tablets. (We cover digital photos in depth in Chapter 4.) Resist the temptation to start sorting or reminiscing yet! There will be time for that later.

TIPS

FINDING PHOTOS IN UNEXPECTED PLACES

Your Immediate Family

As you begin this process, you will find photos of past relatives with whom you may have lost contact. Now is a great time to let them know that you are embarking on this project. Send an email or note telling them what you are doing, and ask if they can help. Do they have old family photos you have never seen? Often, photos get divided between families, and a sister may have family photos that differ from yours.

In many families, one person is the family historian, the one who always has a camera or asks questions about the past. (It

would be good to connect with that person.) I know this is true in my own family. I am an identical twin, and my sister never had any interest in photo taking. She always relied on me to be the keeper of the family stories. If she were starting this type of project, I would be a great help to her.

In addition to my own experience organizing family photos, Caroline Gunther, owner of the Swedish Organizer, interviews experts on her blog, Organizing Photos. The following article, written by Genealogist Lisa Lisson explores a few unconventional places to look for photos of ancestors that you may never have known existed! Here is what Lisa suggests—

Collateral Families

You may find photos of your family members from people not in your family but related to your family members. For instance, if you are trying to find photos of an ancestor, collateral families may be a good resource. Collateral families of your ancestors are those families that are related to your ancestor, but are not in the direct line of descent. Through your genealogy research, you will determine who these families are. Your ancestor's photograph may be in their collection of photographs. For example, Harriet Elliott Richardson and Cynthia Elliott Barnett were the only two daughters of Elias Elliott and his first wife, Panthea Overby. Harriet is my great-great grandmother. I had plenty of photographs of Harriet, and even a couple of her sister, Cynthia. I had no photographs of their parents. Through our Elliott family research, Cynthia's granddaughter and I connected. She shared photographs of Elias Elliott (Harriet and Cynthia's father) and photographs of their brothers, too. Of course, I shared photographs of Harriet's side of the Elliott family with her in return. Our ancestors did not live in a vacuum. They interacted with family and

friends. The descendants of those families and friends may well have photographs of your ancestors. Put on your detective hat and track them down!

Church Histories

We sat around my Aunt Jewel's kitchen table as she shared stories and information about our Howard family history. She showed us photographs, and I learned about her young life and about growing up with her siblings, one of whom was my grandfather. I began to understand how difficult it was for her after losing her mother at a very young age. Then she handed me three small books. These turned out to be the church histories from three small rural churches in Lee County, North Carolina (previously Moore County), that our ancestors had attended. I began thumbing through the first book and came face to face with my great-great-great grandparents! There, on the pages of the little blue book, were Caswell Suggs and Mary Adaline Harward. Often, churches created directories that contained each member's photograph. It is similar to a school yearbook. Church directories and histories frequently contain candid photographs of church members as well, so if your ancestors attended a church that created either of these, you may be in luck.

County History Books

County historical societies create local history books about their families and residents. Information and photographs about individuals and families are collected from local residents who are often descendants of those featured in the book. These short biographical sketches and the county's history are put together in a heritage book. *The Heritage of Halifax County, Halifax, VA*, is one

example of such a county heritage book. Your ancestor's photograph may be contained in the pages of this type of book.

For each family member or family group, contact information is provided for the person who submitted the family history information. You want to contact this person. They are potentially another source of your ancestor's photographs and other family history.[3]

Google, Library of Congress, and Other Ideas

Interest in family history is growing, which means family photos can now be found online. You will find them anywhere, from a family website run by a distant relative to a large public website.

Google: This is by far the most powerful method for locating family photographs online. By searching the web, you will have access to countless family-run genealogy sites, historical societies, image repositories, and more. To search Google for photos, go to "Google Image Search," and type in a name and other identifying information (such as location, date range, or terms such as "genealogy"). You will be amazed at how quickly the photos appear.

Prints and Photographs from the Library of Congress: A large assortment of images of historical interest can be found at the Library of Congress. The various online collections contain a surprising number of photos of everyday Americans—many were taken in the early part of the twentieth century as part of various government initiatives to document American lives. Some images are only available in the Library of Congress itself, but many others can be accessed online.

Dead Fred: This large family history photo archive offers more than 100,000 records online and is available free of charge.

It is fully searchable by name for those images where the people involved are known, while other photographs are still waiting to be identified.

FamilySearch Photos: Find your ancestors in FamilySearch's collection of user-submitted family photos. The special search area makes it easy to look through online images, download them to your computer, or even add your own collection to help other researchers.

STEP 3

IDENTIFYING DATES AND PHOTO TYPES

As you really start to dig into the past, don't be surprised if you come across old photos printed on cardboard and tin or without dates. You can unlock the mystery of these photos by following these suggestions.

The first step in dating nineteenth-century photographs is identifying which technology was used to create the picture. This is straightforward detective work for most images, but very early photographs can be misleading. Numerous types of photographs appeared and then went out of favor throughout the 1800s. The first step in narrowing the possible date for your old photograph is to be able to identify nineteenth-century photographs to determine what type you have. The information provided here can turn you into a proficient photo detective.

The vast majority of antique photographs taken in the nineteenth century were one of the following types: daguerreotypes, ambrotypes, tintypes, cartes de visite, or cabinet cards. Here are the first characteristics you should look for when trying to identify and date old photographs.[4]

Daguerreotype: Is the image shiny like a mirror? Can you only see the image from an angle? Does the back of the image plate look like copper?

Ambrotype: Is the image on a glass plate? Does the image seem to have depth or a 3-D look?

Tintype: Is the image on a blackened iron plate? Will a magnet attach to the plate?

Carte de Visite: Is the image on a thin card approximately 2 ⅜" × 4"?

Cabinet Card: Is the image mounted on a card approximately 4 ¼" × 6 ½"?

Four Common Kodak Brandings: Kodak was the early developer of photos, and you can date photos by the branding on the back of the photos.

Velox: The photo is from the 1940s/1950s.

Kodak/Velox/Paper: The photo is from the 1950s/1960s.

A Kodak Paper: Commonly used in the 1960s and early 1970s.

THIS PAPER/MANUFACTURED/BY KODAK: Commonly used in the 1970s to 1980s. If you have a photo that is advertised as being from 1979, the presence of this branding doesn't prove the specific year of 1979 but is consistent with the date.

Clothing, Hats, and Shoes: Maureen Taylor, the Photo Detective, suggested asking the following question. What are they wearing? Head-to-toe fashion clues tell you about your ancestor's fashion sense (or lack of it), and it can help you narrow down the timeframe even further. For instance, women's leg o'mutton sleeves of the late 1890s, with tight lower arms and full upper arms, look very different from the bell sleeves of the 1850s.

STEP 4

ASSESS THE MESS

Now that you've been gathering all your assets, it's time to assess the mess and take an inventory! You need to know how many photos you have to deal with so you can plan the scope of your project and the time involved. Taking a count of your digital photos can be done in a few clicks but varies by the type of computer. You can find best practices by googling, "how do I know how many photos I have on my MAC or PC". Be sure to look for various formats for digital photos such as JPEG, TIFF, PNG, GIF, and Raw.

Printed photos are a little less exact. Professional photo organizers measure photos or weigh them when estimating. A one-inch stack of photos is approximately one hundred pictures. This number may be less if you are working with older photos that may have a thicker backing. If you weigh boxes of photos, six to seven pounds is the equivalent of 1,000 to 1,200 photos.

> Professional photo organizers measure photos or weigh them when estimating. A one-inch stack of photos is approximately one hundred pictures.

Don't forget to list and count your memorabilia!

NUMBER OF PRINTED PHOTOS _____

NUMBER OF DIGITAL PHOTOS _____

NUMBER OF HOME MOVIES _____

TYPES OF MEMORABILIA _____

STEP 5

CREATE A FAMILY TIMELINE

Preparing a photo timeline aids in the sorting process as you begin to tackle your photo and video collection. Creating a chronological cal list of events will help you as you begin uncovering photos, letters, cards, and newspapers from the past. By placing them along a single timeline, you'll start to get a more comprehensive view of your life even if you don't know exact dates.

> Preparing a photo timeline aids in the sorting process as you begin to tackle your photo and video collection.

What to Include in Your Timeline
- Births
- Marriages
- Deaths
- Moves or emigration
- Religious milestones
- Education
- Military Service
- Employment
- Property transactions

Historical Events:
- Wars
- Famines
- Natural disasters

- Religious intolerance
- Gold rushes
- World leaders, presidents
- Technology, inventions
- Popular books, films, music
- Popular culture, fads

HOW TO CREATE YOUR TIMELINE

Your timeline can be as simple as drawing a horizontal line across the middle of a piece of paper and adding vertical lines to mark and label events. As you look at the entire collection of photos and videos, determine the oldest photo and the most recent photo. This is the time span that you will plot on your map. Once you have these major markers in place, you can begin to jot other moments or milestones in between until you are satisfied with your timeline. Plot your information on the family timeline you downloaded from cathinelson.com, on a spreadsheet in a notebook, or use one of the many websites or apps created for this purpose. You will refer to this often as you start sorting, and details may change based on some of your photo discoveries. Now is a good time to ask your relatives about key dates and events for accuracy, especially if you are working with heritage photos. I found that keeping a notebook nearby was helpful for jotting down questions and memories that you come across; then, you can keep adding them to your timeline.

Now that you have gathered all your printed photographs into one place, you are ready to organize your printed photos. In the next chapter, I will break down this process into manageable steps.

 ## CATHI'S PICS

Photo Organizing Check List and Forms
Download timeline, inventory sheets, etc.
www.CathiNelson.com

Family History Help
Ten Apps for Family History
www.familysearch.org/blog/en/10-cool-apps-family-history/

Dead Fred
http://www.deadfred.com/

Family Search
https://www.familysearch.org/

02
Organizing Your Printed Photos

Now that you have located your lifetime of family photos and have them all in one place, it's time to gather the tools you will need to complete this important job. Think of this as something similar to building a house. First, you need the foundation and then the tools. There is a famous saying that you are only as good as your tools, and there are some essential tools you will need to complete this project. In this section, I will help you determine the best tools to have on hand. I will also introduce some of the challenges you will face and give you advice on what to do.

STEP 1

SUPPLIES YOU WILL NEED

A photo organizer's supply kit includes cotton gloves, face mask (for moldy photos), garbage bags, empty bins, photo sort box, sticky notes, index cards, photo labeling pencil, dental floss, a tablet or smartphone, and an external hard drive.

> A photo organizer's supply kit includes cotton gloves, face mask (for moldy photos), garbage bags, empty bins, photo sort box, sticky notes, index cards, photo labeling pencil, dental floss, a tablet or smartphone, and an external hard drive.

Before you get down to business, you'll need to collect some supplies. I polled personal photo organizers for their supply list; these are the "must-haves" when they begin any photo organizing project.

Cotton gloves: Fingertips contain an oily residue that will further deteriorate your delicate photo.

Face mask: If your printed photos smell musty, or they were stored in an attic or basement, they may contain mold spores that you could find irritating during the sorting process.

Soft-lead blue or black art pencil: As you sort photos, you may want to include a date, year, or name on the back of a photo. This pencil is not a permanent marker, and it will not indent or harm your photo. It will, however, record essential information until you can store the details digitally once scanned. Never use a pen to mark the back of your photo.

Index cards: Jot down more details, facts, stories, and dates on index cards and group them with printed photos. Index cards

can be scanned with printed photos, so important details remain grouped together.

Archive-quality photo-safe storage box: Choosing a good quality photo box will keep your photos safe and aid in the sorting process.

Temporary holding containers: As you begin the sorting process, you will need a way to identify your A and B photos (see Step 2). I have used everything from tin baking pans to large narrow plastic boxes you can pick up at any retail store. Remember, this is not meant for permanent storage but only as a holding place as you sort and organize.

Dental floss and hair dryer: If you have peel-and-stick albums, some of your photos may be difficult to remove. Surprisingly, dental floss and a hair dryer can help you remove those photos from albums.

Smartphone camera: If you have old albums with details on the page, you can take a snapshot of the page to keep the details with the photos.

Sticky notes or a notebook: These come in handy for creating a timeline during the sorting process.

External hard drive (EHD): Choose a high-capacity drive according to the number of images you have. If you are also keeping your videos on your EHD, I recommend one terabyte (TB) which will have plenty of room for your photo and video collection. You can fit approximately 500 hours' worth of movies on one terabyte or close to two million photos of average size.

Garbage bags: You'll come across toss-away pictures, artwork, and meaningless ticket stubs that will help reduce your clutter. Let's set a goal to fill a bag!

These are the essentials, but you may have some other ideas as well. Some organizers use apps such as Evernote or OneNote to

curate information or create timelines. Whatever makes your job easier, add it to your list.

TIP

REMOVING PHOTOS FROM ALBUMS

As you organize and sort your photos, you may come across old scrapbooks, pocketpage albums, and old magnetic albums that were popular about twenty-five to thirty years ago. Unfortunately, many of these albums are accelerating the deterioration of your photos and should be removed.

The biggest offender is the magnetic or sticky album. The glue on the page surface, the acidic cardboard page, and the plastic overlay create a "chemical sandwich" that is rapidly destroying your photos.

If you have these albums in your collection, removing the photos is a priority! Some may be easy to remove, and some may be troublesome.

Here are a few tips as you approach this next step:

1. Find a photo in the album that is a "throwaway" and try to remove it first by gently lifting a corner. If it comes up easily without having to pull or curl the photo, then proceed.
2. If the picture is stuck, take a thin metal spatula and gently work under the photo, or slide a piece of unwaxed dental floss under the corner and gently saw back and forth to work through the adhesive.
3. Try heating the back of the photo slightly with a blow dryer then attempt the dental floss again. Or heat the metal

spatula, and use this to soften the glue as you work behind the photo.

4. Try using a product like Un-du, which is an adhesive remover used by scrapbookers and is safe to use on the backs of photos.

If all this fails, then leave your photos in the albums and make duplicate copies with a flatbed or mobile scanner.

TIP

DAMAGED PHOTOS

You are likely to come across photos that have been damaged, faded, scratched, worn, and torn. Photos are made using chemicals and dyes that are sensitive to light, moisture, and changes in temperature. Over time, these chemicals degrade, and the image starts to fade away, turning yellow and developing cracks. Dust, oil, dirt, and gases contribute to print deterioration.

Prints were only meant to last for so long. The negatives from which they were originally made are likely lost or destroyed. Saving these analog memories from their inevitable destruction can be as easy as a one-click desktop scanner, but sometimes the images have already suffered damage. Subscription software such as Vivid-Pix, Perfectly Clear, or Adobe Photoshop can breathe life back into faded photos if you know how to do it right. There are many tutorials you can watch to learn, or you can save yourself time and have a professional restore your photo. It's amazing the work they can do. You can search for a professional in your area through www.appo.org or at your local photo retailer.

TIP

PREPARE FOR EMOTIONS

Photography is a beautiful means to reflect back on our lives, both the good and bad. Our families are important, and every family has a story. Love is important. Relationships are important. Joy, fulfillment, integrity, authenticity…also loss, heartache, and feelings of nostalgia. All of these emotions will arise as you open the boxes. Be prepared, or allow yourself to take the time you need to grieve, or go for a walk, write in a journal, or cry a few tears. Don't hesitate telling your family and friends that you are embarking on a journey and that you may be sad for a few days. That is totally normal.

Nostalgia is Healing

"Nostalgia is where the healing happens," explains Alan Pedersen, Executive Director of the Compassionate Friends, an organization that offers support to nearly one million bereaved parents, siblings, and grandparents across the United States. "We used to think it best to keep memories at bay because they were too painful. This is old thinking. We now say reminisce to the hilt."[5]

> "We used to think it best to keep memories at bay because they were too painful. This is old thinking. We now say reminisce to the hilt."

STEP 2

THE ABCS

Do you remember when we took our film to be developed at the local photo lab or grocery store? We would drop our film off for

one-hour developing and get doubles or triples so we could give the extra to family or friends. Did you even make it out of the parking lot before you were flipping through the envelope for your "first look" at these photos?

The problem with this "era of convenience" was its contribution to excess and waste. Our good intentions produced boxes and boxes of printed photos that accumulated through the years, and we're paying for it today. I am sure you have come across photos in envelopes you haven't looked at since the day you picked them up!

That is why I developed a simple method to help my clients sort their photos using an easy-to-remember acronym—the ABCs. This is now used by hundreds of photo organizers throughout the world. Many people find it helpful to keep them on track as they start to dig in to their piles of photos.

A **is for Album:** These pictures are the best of the best! The ones that belong in an album and the memories that you would mourn for if you lost them. These are the photos that you'll want to digitize, backup, share, and display. It doesn't mean we're going to put all these pictures into albums; it just means they are "album worthy." As you come across *A* photos, add them to your *A* containers, or pile or make sure you identify them with a sticky note.

B **is for Box:** These photos are the extras that support your best. They are the ones you aren't ready to part with but want to have access to at some point in the future. These photos will be archived for safekeeping but not necessarily digitized. Start adding these to your *B* container.

C **is for Can:** Yes, you CAN repurpose these pictures or throw them in the trash can! Your collection is filled with doubles, triples, and REALLY BAD photos. If your photo doesn't fall into one of the previous categories, then it's a *C* photo. We encourage you to be brutal here and set a goal to fill a garbage can with these!

TIP

PHOTOS TO DISCARD

I suggest you eliminate many of your scenery, sunsets, and famous travel sites. If you traveled to the Grand Canyon you likely have hundreds of photos. Try and narrow down to your favorite two or three because the Grand Canyon will still be there years from now, but the photos of people won't be. In fact, my rule is to eliminate 80 percent of your photos and keep your favorite 20 percent! That means keep only twenty out of every one hundred.

> I suggest you eliminate many of your scenery, sunsets, and famous travel sites.

S is for Story: Does the photo tell a story? These pictures play a significant role because there is something illustrative about the picture even though it may not be obvious. A picture of a single tree in the backyard may seem meaningless unless it's the full-grown sapling your great-grandpa had planted before he passed away. Or does the photo of your dad making a silly face remind you of how, as a teen, you were embarrassed by him, but today you would give anything to see that smile again? Those are the S photos, the gems within your collection, the photos that matter and tell a story. Depending on what works best for you, you can either put these in a special container to review later or take the time immediately to write down the story on either the index card or sticky note you collected prior to beginning. If you use the Who, What, Where, When, and Why of basic journaling, you will capture all the necessary information.

ORGANIZING BY DATE OR THEME

Many people start to become overwhelmed at this point! Especially if your photos are not in date and time order. Are you finding yourself worrying what year a photo was taken and whether your son is five or six in a photo? Well, don't panic. You don't have to organize chronologically. I always like to say we take photos chronologically, but we live and remember thematically.

> I always like to say we take photos chronologically but we live and remember thematically.

Think about how you like to view family photos and memories. Isn't it interesting to see a collage of images of birthdays that show a growing child or family vacation photos over the course of many years? There is no "rule" that photos have to be organized into a time and date order, which is what I mean by saying we live thematically.

As you survey your photo collection, you most likely will see that the majority of your photos are related to themes, such as birthdays, vacations, weddings, graduations, babies, holidays, first days of school, sporting and school events, along with the everyday photos of the people we love and who love us. Now is an important time to consider which organizational approach you want to take. I have outlined the pros of each.

Pros of Organizing by Theme

- **Themes make it easier to pull together a photo album**. Put an entire theme into one album or photo organizing box. For example, your collection may consist of photobooks and photo

boxes labeled like this: We love to travel, We love to Celebrate, We love the arts and music.

- **Themes are easier to identify than dates.** You may not be sure which year a Christmas photo was taken, but you'll know it's Christmas!
- **Themes translate into tags and keywords.** Once digitized, themes make it easier to determine keywords or tags when you move them into your digital photo hub.

If your photos are a mess of disorganized prints with no structure, then I recommend a theme-based approach.

Pros of Organizing Chronologically

If you already have some chronological organization in place, then keep this intact and look for ways to build on that structure. Now is a good time to use your family timeline so you can keep track of important dates and years. You can still identify themes and group photos based on your end goal.

With your structure established, set up some index cards in sorting boxes or on a table, and use these to group your photos as you sort. Jot down details on the index cards so they can be scanned in with your prints.

TIP

PACE YOURSELF

Two-Second Rule: As you sort your photos, resist the urge to reminisce and linger. There will be plenty of time for that later. Don't hold your photo for any longer than two seconds or the time it takes to determine its pile.

Set a Timer: This can be tiring work so set a timer for one to three hours maximum and give yourself time between sorting sessions. Don't get discouraged if this is taking longer than you anticipated. You didn't live and take all these photos in a few days, and you won't be able to

> Don't hold your photo for any longer than two seconds or the time it takes to determine its pile.

sort through, identify, and organize them in a few days either. This is your life history, so it's worth taking your time and committing to the process.

STEP 4

STORE PRINTED PHOTOS SAFELY

Your printed photos and memorabilia should live where you do.

That means they should be stored in archival containers and located in rooms with average temperatures and low humidity. Avoid basements and attic.

> Your printed photos and memorabilia should live where you do.

Your last step in organizing your printed photos is to determine where you want to store them once you have sorted using the ABCs and scanned them, which we will talk about in the next chapter.

Printed photos (and memorabilia) should be stored in containers designed for archiving. To be considered *archival*, products must meet rigorous standards developed by the Image Permanence Institute. This is achieved by passing the Photographic Activity Test (PAT). The PAT test is the international standard for photographic archival storage, and you can learn more about it at the Image Permanence Institute website.

Before you place your scanned prints and memorabilia into their storage containers, wipe the surface of each photo with a clean, lint-free cloth to remove any residue or dust that may be on the picture. And of course, wear your gloves!

Your photo boxes and containers should be stored at room temperature with 40 percent humidity levels and away from light. Stay away from basements and attics and keep them off the ground, preferably on top shelves or the second floor of your home. When floods occur, homes fill from the basement up. Even though this collection has been digitized, (see Chapter 4 on how to save your digitized images) and backed up with the rest of your digital images, you should strive to secure your originals to the best of your ability.

Now we are ready to talk about scanning your photo collection. This important step will ensure your photos are safe for generations to come.

CATHI'S PICS

Photo Organizing Supplies
Archival Methods
https://www.archivalmethods.com/

Adhesive Removal
https://www.un-du.com/

Photo Restoration
Vivid Pix
https://www.vivid-pix.com/

 # CATHI'S PICS (cont.)

Adobe Photoshop
https://www.adobe.com/

Perfectly Clear
http://www.athentech.com/assets/perfectlyclear/

Personal Photo Organizer
www.appo.org

Industry Standards

The Image Permanence Institute
https://www.imagepermanenceinstitute.org/about/about-ipi

Library of Congress
http://digitalpreservation.gov/personalarchiving/

Online Classes

Creative Live
https://www.creativelive.com/

Lynda
https://www.lynda.com/

My Workflow Studio
https://www.myworkflowstudio.com/

Digital Photo Organizing Pro
http://theswedishorganizer.com/dpopro/

03

Scanning Your Photos: Everything You Need to Know

This chapter builds on the organizational structures we talked about in Chapter 2, because the more organized you are prior to either scanning yourself or sending your images away to be scanned, the easier it will be to add them to your photo hub, which I will discuss in more detail in Chapter 4.

Now is the time that your timeline we discussed in Chapter 1 will come in handy.

Scanning your printed photos and slides extends the lifetime of your pictures, creates a backup, and increases your ability to share and enjoy your memories. Yet this can seem to be an overwhelming piece of the puzzle. Do you scan them yourself or send them away to a scanning professional? Should you scan all your

photos or only the best? What about slides, negatives, children's artwork, and newspaper articles? These are great questions, and we will address each one in this chapter.

STEP 1

BENEFITS OF SCANNING

Scanning Extends the Life of Your Photo

Your printed photos will decay and deteriorate even under optimum storage conditions. When you make a digital copy of a photo, you have the ability to enhance the image, restore it to its original color, make copies, and fix damage. Once your printed photo is digital, it can be migrated into new forms as technology changes, extending the life of your image beyond the original print.

Scanning Creates a Backup of Your Printed Images

Right now, you have one copy of those prints with no backup unless you were particular about saving and cataloging your negatives. What happens if there is a fire or flood and your only copies are destroyed? Scanning your photos creates a backup to ensure your family photos are safe and follows the first rule of preservation: replication, redundancy, and planned migration.

Scanning Increases Your Ability to Share and Enjoy Your Photos

Families with printed photos face similar dilemmas. How will I divide my printed photos between my kids? Who gets what? What

if they have storage space issues? I created scrapbook albums, and everyone in my family wants one! When you have digital copies of your photos (and your albums), your problems are solved. In their digital form, your printed photos can be shared via social media and online photo archives or put into slideshows and photobooks.

> When you have digital copies of your photos (and your albums) your problems are solved.

In this next section, we will review scanning terms, types of scanners, and the many options to consider when starting this project.

TIP

UNDERSTANDING SCANNING TERMS

Metadata: This is a fancy word for memories. Just like your grandmother's handwriting on the back of old photos, metadata is how your grandchildren will learn about you and your legacy. And just like your grandmother's script, the metadata you add to your photos today will bring your family history to life for future generations.

Metadata is important because it describes key information about the digital files (image files, text files, digital audio/video) and, when appropriate, the original objects they represent. It also allows information to be transported with the photo in a way that can be understood by other software, hardware, and end users.

It is important that the metadata stored in an image stays with the image. This will allow you to search your photo collection decades from now. There are different kinds of metadata, including bibliographic (author/artist, publisher, publication/release date), technical (related to software things such as scanning equipment,

software programs, settings used to create/modify the file), preservation, and structural (how the original item is put together hierarchically, such as page numbers, titles, chapter headings, etc.).

DPI: This is important because dots per inch (dpi) is the number of pixels that fit onto a one-inch-square space. For an image to print properly in the future, it needs to be scanned with a minimum of 300 dpi because once an image is scanned you can't increase the resolution. For example, if you scan an image at 72 dpi, the printed image will be very blurry. Slides and negatives need to be scanned at a much higher dpi. We recommend 600 dpi for photos and 2000 dpi for slides.

JPEG vs. TIFF: It can get very confusing when trying to understand the difference between these two file formats. Each one has its unique benefits and is better suited for certain people or situations.

> **JPEG:** The standard file format of most of today's consumer-quality digital cameras. It is supported by almost all of today's imaging software. JPEG uses compression, meaning that some image data is lost when the file is compressed. The amount of compression can vary: the more compression, the more data is discarded, and the smaller a file becomes. JPEG is great for creating smaller file sizes for uploading on the internet or for use with email. It's also a good choice because it is very popular and likely to be around for a long time. Just be aware that if you plan to edit a photo and then re-save it, you will lose some quality each time.

> **TIFF:** The standard for most commercial and professional printing needs. TIFF is a great choice for archiving images when all detail must be preserved and file size is not a consideration. TIFF

files are very large in size compared to JPEGs because no compression is used, which means this is better if you plan to edit. Your photo won't degrade in quality each time it is edited.

Scanning Prints vs. Slides vs. Negatives: Scanning film, slides, or negatives will almost always produce better digital images than scanning prints and photos. Slides and negatives are the original. Prints are second generation copies of the original film and do not contain as much information or detail as the negative from which they were made.

If you have the option of scanning a negative instead of scanning a print made from the negative, we recommend scanning the negative. However, if you are like most of us, you may have lost or misplaced your negatives, or your negatives may not be organized or may be in poor condition. If this is the case, scanning your prints is a great alternative.

Now that we have covered the basics of scanning, we will explore the different types of scanners and the pros and cons of doing it yourself or sending your photos away.

STEP 2

CHOOSING THE RIGHT SCANNER

Types of Scanners

Flatbed Scanner: You may already own an all-in-one home printer, which probably includes a scanner that looks like a photocopier. If so, you already know that the item is placed face down on a glass plate, and a scanning array captures the image from below. Flatbeds work very well with flat, single page items. They can be used to scan bound materials, but this subjects the binding to stress and

may cause damage. If you plan to scan only a few hundred photos, this is an excellent option. However, if you are going to scan your entire collection, software glitches typical to these home printers could make finishing your work troublesome.

Auto Feed or Sheet Feed Scanner: This consists of an attachment to a flatbed scanner that allows the scanner to work through a stack of loose pages unaided. Some auto-feeders redirect the page to the flatbed via rollers, and these may curl the page, causing damage to fragile or brittle paper. Other models of auto-feeders have separate scanning arrays that allow the feeder to scan the page without curling the paper.

Planetary/Overhead Scanner: This is a scanner that is set up like a copy-stand camera: the scanning array is fixed above the scanning bed rather than under it (as with flatbed scanners). Overhead scanners are generally less damaging to bound materials.

Digital Back or Camera Back: This is a traditional film camera that has been fitted with a digital image array in place of the film. Digital backs can be used with 35mm film cameras or copy-stand cameras.

Mobile Scanner: This is a small, battery-operated, portable scanner. I use my Flip-Pal to quickly scan photos in scrapbook albums for instant sharing to social media.

You know the saying, "There is an app for that." Well, that applies to scanning apps for your mobile phone.

Scanning Apps: The two most popular are Photomyne and PhotoScan. These allow you to use your smartphone's camera to scan and save your pictures. Both apps offer further organization through cloud storage options. You can download a free trial of Photomyne or pay a monthly fee to experience the full extent of tools available through the app. PhotoScan is free. These apps may be insanely cheaper than buying or renting a scanner, but cellphone cameras will not produce the quality that a scanner guarantees,

and it will take longer to scan your photos because you will probably have to scan one print at a time for the best results.

Rent a Professional Scanner: If you have a large collection of photos, you can rent a professional high-speed scanner that scans up to 800 photos an hour. E-Z Photo, whose headquarters are in Orlando, Florida, offers excellent customer service and rental options. You can go to their website or call their customer service number, and, by working with their support staff, you can determine whether this is a cost-efficient option. If you spend the time getting organized and then set aside a weekend, you can complete your project efficiently and affordably.

VueScan is a software program that can take the place of the software that comes with the scanners. It is easy to use, as well as having over 50 advanced features. It provides a very easy-to-use interface for scanning photos and film and it also works with older scanners that may not have supported software. VueScan supports over 5,500 different types of scanners on Windows, Mac OSX, and Linux. Kathy Rogers of Baltimore Photo Solutions said, "I love VueScan, it really does bring life to old scanners." You can test VueScan for free from www.hamrick.com.

Your Camera and Lightroom

Camera scanning can be done on-site, with any of the millions of high-quality digital cameras already in use by people and institutions. For many, the only additional purchases may be a modest outlay for a macro lens or a copy stand.

Peter Krogh is a world-renowned subject-matter expert on Digital Asset Management for photographic images and offers consulting services for all components of image preservation, management, and access. He recently wrote a book called *The DAM Book Guide to Digitizing Your Photos with Your Camera*

If you scan from home, take extra care when handling your photos. Wipe your printed photos with a clean cloth and keep the scanner glass clean and dust free. Scanners will pick up dust, scratches, and smudges and magnify them in your image.

and Lightroom, which presents a comprehensive step-by-step guide for equipment selection, photo preparation, scanning workflow, tagging, curation, and digital photo management. Drawing on the principles used by museums and institutions, the book presents a method that is within reach of millions of photographers, whether they are family historians, corporate collection managers, or professional archivists.[6]

If you scan from home, take extra care when handling your photos. Wipe your printed photos with a clean cloth and keep the scanner glass clean and dust free. Scanners will pick up dust, scratches, and smudges and magnify them in your image.

STEP 3

PROS AND CONS OF DIY OR SENDING TO EXPERTS

Is DIY Photo Scanning Right for You?

- **Pros:** Taking on the task of photo scanning yourself can be a fun way to reconnect with your memories. Because you are in control, you can curate your collection during the process to avoid creating a digital mess of your photos.
- **Cons:** Finding the time and motivation to get the job done has proved difficult for many. Technology glitches are time-consuming and test patience.

Ship Photos to a Scanning Service

You can also send your photos to a professional scanning company. As you are researching and selecting a company to use, you should look for the number of years they have been in business and if they send your photos elsewhere for scanning. You must ensure that the company you ship your photos to holds itself to the highest level of commitment when it comes to digitizing your photos because these may be your only copies. I have listed my favorite companies in Cathi's Pics.

Is a Mail-in Company My Best Option?

- **Pros:** Mailing away your photos is often cost-efficient, with prices ranging from 4 cents to 59 cents a photo. Many companies also offer a range of upgrades, such as color correcting, slideshows, and cloud storage.
- **Cons:** Many people are afraid to put their valuable photo collection in the mail. And, if you ship a box of unorganized photos, you will get the same mess back in digital form.

Hire a Local Professional

Despite the several options outlined previously, many of us struggle to find the time to begin the process. The growing trend of digitizing our massive amounts of prints lying around in dusty shoeboxes has allowed for the emergence of professional photo scanners and organizers. There is a growing niche for people interested in creating a business by organizing a family's history, and a major part of the business involves photo scanning. Personal photo organizers reside all around North America and in other parts of the world.

Is a Local Professional the Most Helpful to Me?

- **Pros:** Professional photo organizers and scanners save you time, and many will pick up the photos from you if you don't have a moment to drop them off. Some have the tools to scan right in your home, and they will organize your collection before they scan so that they can duplicate this organization digitally. You can locate a personal photo organizer near you by going to www.appo.org and clicking the "find an organizer" tab.
- **Cons:** Professional photo organizing is still a growing business, so there may not be someone available in your area. Also, not all photo organizers are certified through the Association of Personal Photo Organizers, so you will want to choose your professional with care. Don't hesitate to ask for references and interview the individual to ensure that you are comfortable before handing over your precious photo collection.

While there are advantages to DIY photo scanning, getting your photos scanned by professionals—including individual photo organizers, local retailers, and mail-in services—will offer you convenience and time savings. You'll also know that your family history will be scanned to industry standards and archived effectively for you to have as a keepsake forever.

STEP 4

SCANNING SLIDES

Converting slides to digital photos can be tricky. Unlike old photos, a certain finesse is required when scanning slides. Once again, consider whether you want to DIY or have an expert do it for you. If you have a large number of slides that need to be

converted to digital photos, there are several ways that you can accomplish this task.

Purchase a Slide Scanner

There are scanners specifically made to scan slides, but they can cost anywhere from $50 to $200. This is best if you want to go the DIY route when converting slides to digital, but keep in mind that the process is tedious. Generally, the more expensive the scanner, the better-quality photos you'll get in the end.

Be sure to look for a scanner that cuts down on scanning time and has a large mega-pixel number. It will produce higher quality results. Most importantly, ensure that your scanner is compatible with your computer. It's never fun to arrive home excited to start a new project and learn that you just have to return it the next day.

Use a Flatbed Scanner

If you don't want to commit to a specialized slide scanner, you can use one that you already own. Doing so might just mean you need to make some modifications. Look for a mount holder, which will allow you to preview your slides quickly once they're digital photos. This way, you can discard and save without wasting time. Pay close attention to light and resolution as well because a normal scanner might distort the original slide quality.

Scan at a Higher DPI

It is said that the best resolution and format to be a high-quality JPEG is at 2,000 dpi. You can scan at a higher dpi and use another format, such as an uncompressed TIFF file. You would really only

need to use a TIFF file if you're planning on making a very large print or poster of the image once it is digitized.

Photograph Your Slides

Get out that slide projector, and take a picture of each slide as it's screened. Manually adjust your focus and experiment with shutter times to find the right setting. Or use a slide viewer that will help you take a picture of a slide when lit from behind. You can always take a close-up image of the slide as well and edit it with photography software.

<div align="center">

STEP 5

</div>

SCANNING NEGATIVES

By now, you may have come across your original envelopes with the negatives tucked safely away. How many of those negatives to keep or toss is always a difficult question, but let's start out with an overview of what a negative is exactly and then offer best tips for storing and handling negatives. For help, we turn again to Caroline Gunther of Organizing Photos who interviewed Cora Foley of SmoothPhotoScanning.com.[7] Cora shared the following.

What Exactly is a Negative?

Negatives are an amazing form of analog media that can contain rich history within them, but they're very sensitive and require proper care to ensure the treasures within them aren't lost forever.

A negative is considered the "first generation" of a visible image. It's produced when an unexposed, emulsion-coated piece of plastic is moved through a camera to the lens area. This causes the film to

be exposed to light and creates a reaction. The film is then rewound back into an unexposed area of the camera. Once the film is chemically developed, an image will appear, creating the negative you find in your photo collection. Based on the type of camera that was used, you might have differently sized negatives, including 35mm, 110 format, 126 format, medium format, and large format.

Nowadays, a negative is typically found on a thin sheet of transparent, plastic film, but originally, they were made on paper and subsequently transferred to thin sheets of glass. Although it's important to note that while a negative is always on a transparent material, just because an image is transparent doesn't necessarily mean it's a negative. In black-and-white photographs, the lightest colors of the image appear dark in a negative, while the dark areas of the photo appear light. Color negatives appear in the complimentary color version of their photo counterpart.

Should I Keep or Toss My Negatives?

There is a lot of debate as to whether or not you should keep or toss your negatives.

Pros: They contain the most image detail, meaning they produce the highest quality prints and digital images. Scanning them directly to a digital image increases the clarity and color of an image.

Cons: They are typically small, making it hard to tell what images you have, and they are extremely delicate and easily succumb to damage. If a negative is the first generation of an image, that makes the printed photo the second generation and your scanned digital image the third generation. In this derivative process, image quality is lost, so the best way to obtain the highest quality digital images is to scan a negative directly to

a digital image. If you have unharmed negatives and room to store them, we recommend saving them until you're able to scan them, because if you can produce a higher quality image, why not do so?

Proper Negative Storage

Storing negatives properly is imperative to their safety. Because negatives are so delicate and the film is so thin, they are at a high risk for damage, including elemental damage (moisture, heat, and light), oil damage, scratches, and deterioration. They require special storage to ensure their longevity or they won't be able to produce a high-quality print or digital image. Some damage may even prevent you from retrieving the image at all.

Storage Do's

- When handling your negatives, make sure your hands are clean and dry. Only hold them by the edges (the oils in your hands can damage them).
- Make sure your negatives are free of dust and dirt, prior to storing them. If you notice dirt and dust, you can use canned air to blow off any debris.
- Put clean negatives in polyethylene sleeves. This kind of plastic is safe and won't cause any damage to film.
- Make sure to store negatives flat. We recommend you put them into sleeves and store them in a binder or lay them flat in a plastic box made of polypropylene.
- Store negatives in a cool, dark, and dry environment where the temperature doesn't fluctuate much.

Storage Don'ts

- Make sure you don't hold the negative anywhere but by the edge.
- Don't stack negatives. Any moisture in the air can cause the sheets of negatives to stick together. This could cause distortion and rips, and even completely destroy the film.
- Make sure your negatives are stored flat. Film easily warps, which causes image distortion and makes it difficult to scan (the film can actually crack and fall apart).
- Don't store your negatives in the attic or your garage (or where the temperature fluctuates rapidly). This increases the rate of decay.
- Store negatives in a low humidity environment. Moisture can cause the negatives to stick to their surroundings (ruining the images they contain and potentially destroying the whole film).

STEP 6

THE COPYRIGHT CONCERN

This section is among the most overlooked but most important conversation when scanning images. Many people make an assumption because they own a photograph from a professional photographer that they can scan it and use it any way they like, but that is not true and is a violation of copyright. Don't panic, we have consulted with a few experts who share their advice with us.

Caroline Gunther interviewed Jackie Jade, an attorney and blogger about copyright concerns and fair use of photographs.[8] Here is what Jackie had to say—

"We are lucky to live in an age where it is so easy to capture moments on camera. Plus, we have all of our old family photos on hand too. Obviously, digitizing photos is really popular right now, but copyright issues are always a concern, so let's discuss what is and isn't okay when it comes to digitizing your personal photos, or photos for others.

Before we get started, I want to let you know that I am a U.S. attorney and a member of the Bar in Pennsylvania. Therefore, the information in this post is based on my knowledge of U.S. law, but the information may be applicable to readers in other countries as well. Additionally, this blog post is for informational purposes only and is not legal advice. Consult with a local attorney for legal advice.

What is Copyright?

First, let's discuss what a copyright is since copyrights are the main issue when dealing with photographs. Copyrights are the legal system that give the creators of work the right to control the copying of their work. This means that others can't take, use, or reprint their work without their permission. The point of this is to protect the original creator of the work. When it comes to photographs, there are several different legal issues you can run into, so I'm going to broadly discuss them today.

In the U.S., creative works are copyright protected from the moment that they are created. This means that the creator of the work immediately has copyright protection without needing to actually register the work with the U.S. Copyright Office. However, in order to file a lawsuit, the work needs to be formally registered with the U.S. Copyright Office.

The Purpose of Copyright Laws

The purpose of copyright laws is to promote creative works by giving authors or creators a limited time exclusive right over their works. Basically, the laws want to balance the public's interests of repurposing or copying content while also protecting the rights of artists and creators so that they have an incentive to continue to create unique creative works (because they know their work can't just be taken and used by anyone for any reason). So this can be good and bad. If you are the creator of something, this is a good thing—it means that people aren't going to constantly steal and reuse your stuff without your permission. But sometimes it can be a bad thing too—such as the situations with photographs where we often don't know who the copyright holder is.

Copyrights and Photography

When it comes to photography, the photographer has the exclusive right to reproduce their photographs. This means that it is unlawful for others to do anything with these photographs without the photographer's permission. This includes making prints, copying, scanning, photocopying, emailing, publicly

> When it comes to photography, the photographer has the exclusive right to reproduce their photographs.

displaying, or creating 'derivative works' the photos. This makes sense because part of a photographer's livelihood is having the control over copying of the photos that they take so the law protects them. Additionally, owning a copy of a photo isn't the same as owning the copyright, which is the ownership of the intangible intellectual property.

So Who Owns the Copyright for Old Family Photos?

This can be dicey when it comes to copying old family photos. You might think that the person in the photo or the person who paid to have the photos taken would be the copyright owner, but the copyright is actually owned by the person who took the photo—the photographer. Remember, this makes sense under the purpose of copyright laws because the law wants to protect the photographer and his or her livelihood.

The creator of a work owns the copyright from the moment the work is created. The length of time that the person owns the copyright depends on several factors, but it can be upwards of 120 years after the photo was taken. This is true even if we don't know who took the photo because we can assume that whoever took the photo still owns the copyright. If the photographer is deceased, the rights over the photos would have passed according to the photographer's will or through succession laws if he or she did not have a will. There are some instances where the photographer can transfer the copyright to someone else, such as a wedding photographer, giving the couple the full rights to copy and reprint the photos. This would need to be done in writing and signed by the copyright owner.

How to Legally Copy Family Photos

Ok, so I know you want to know—is it legal to make copies of your family photos? Well … it depends. How can you make or obtain legal copies of professional photos?

First, you should contact the photographer or the copyright owner. The photographer will likely be more than happy to go over options for

Is it legal to make copies of your family photos?

reproducing photos, or they can give you a license for copying or making your own prints. With older photos, it can sometimes be tough to figure out who the copyright owner is. One option is to go to the Photographer Registry website in order to find out who the copyright owner is. If the photographer or copyright owner is deceased, the rights would have passed through the person's will or through the estate rules. If the photographer is alive but no longer in business, you can see if they have transferred or sold the copyright to someone else.

Consider the issue of fair use if you cannot figure out who the copyright owner is or if the photographer is out of business or deceased. If your copying or scanning can be deemed 'fair use', this would be a defense to a claim of copy-right infringement. A court would look at factors such as if you are transforming the

> Consider the issue of fair use if you cannot figure out who the copyright owner is, or if the photographer is out of business or deceased.

work, if you are copying for a commercial reason, whether your copying would be detrimental to the photographer, or other similar factors.

Basically, the Law Surrounding the Copying or Reuse of Old Photos is Murky

As a rule, try to first get permission from the copyright owner (likely the photographer). If you can't find the photographer, try to find out who might own the copyright. If you still aren't sure who the owner is, determine if your copying could fall under fair use as a lawful way to reproduce the photos. There are no hard and fast rules and every situation will be different. But this is a great general guide to get you started."

STEP 7

SCANNING NEWSPAPER ARTICLES

I checked in with Diana Uricchio of OXO Digital Organizing about scanning newspaper articles and this is her advice, "Newspaper clippings are a big part of many collections. Usually these can simply be scanned on a standard flatbed scanner. However, sometimes the clipping will be too long or wide. Some document scanners will have a protective sleeve that will allow you to insert the clip, then process it through the scanner feeder. If the piece is still too large, it may be necessary to scan it in two parts, then 'stitch' it together in a program like Photoshop."

If your newspaper clipping is really thin, consider putting a black-colored paper behind it. This helps the scanner ignore any bleed-through print from the other side of the newspaper.

> If your newspaper clipping is really thin, consider putting a black-colored paper behind it. This helps the scanner ignore any bleed-through print from the other side of the newspaper.

STEP 8

SCANNING CHILDREN'S ARTWORK

We all remember those craft projects we did back in elementary school. As a parent (or grandparent), we proudly display our little one's artistic samples on the fridge or keep them in a memory box. These beautiful works of art are a whole different ballgame when it comes to scanning. First, the waxy crayon, sticky glue, and other textures can make it impossible to run through a scanner. Even a

flatbed may not be able to digitize the macaroni sculpture, glitter piles, or oversized cut-outs from grade school.

Consider taking pictures of these masterpieces. Simply lay them on the ground in front of a window for great natural light, and snap away. Another option is to use a book scanner, like the Fujitsu SV600. This allows you to digitize without disturbing the artwork or damaging your scanner.

Use Your Mobile Phone

Keepy.me is an app with a creative mission and an archival method for the twenty-first century. It allows you to archive your children's masterpieces digitally with your phone or tablet.

When storing, you can save the content with your child's age within the app, and you can also do a voiceover to attach to the photo of the item. This keeps the story with the digital artwork.

For example, if you take a photo of your child's artwork, your child can record in his or her own words what it is. You can also share the artwork with friends and family members, who can then respond via video. This data will remain attached to the artwork within the app.

STEP 9

SCANNING LETTERS, COINS, AND OTHER KEEPSAKES

Besides loose photos, albums, and scrapbooks, you will likely have letters, cards, or other mementos. The key is to get creative and capture the memory you want to preserve. For the non-standard

pieces that are delicate but still flat, you can use a flatbed scanner. One of the best ways to achieve quality photos of 3-D objects and keepsakes is by using a small light studio, such as SHOTBOX.

Now that your images are scanned, you need to organize the mess. It's time to move on to Chapter 4, Organizing Your Digital Photos.

 CATHI'S PICS

Forms
Printed Photo Checklist
Physical Photo Inventory
Individual & Family Timeline
Go to www.cathinelson.com to download the forms

Digital Preservation and Outreach
http://digitalpreservation.gov/education/index.html

Photographer Registry
http://www.ppa.com/about/content.cfm?ItemNumber=1753

Flatbed Scanners
Epson Scanner V600
https://epson.com/For-Home/Scanners/Photo-Scanners
Epson-Perfection-V600-Photo-Scanner/
Canon CanoScan 9000F Mark II
https://www.usa.canon.com/internet/portal/us/home/products/

Mobile Scanner
Flip Pal
https://flip-pal.com/

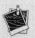 ## CATHI'S PICS (cont.)

Rent a Scanner
EZ Photo Scan
https://ezphotoscan.com/

Scanning Apps
Photomyne
https://www.photomyne.com/

Scanning Software
Bring your old scanner back to life
VueScan: https://www.hamrick.com/

Lightbox App
Light Box—Illuminator Viewer
https://itunes.apple.com/us/app/light-box-illuminator-viewer/

Recommended Book
The DAM Book Guide to Digitizing Your Photos with Your Camera and Lightroom by Peter Krogh
http://thedambook.com/dyp/

Scanning Companies
Fotobridge
http://www.fotobridge.com/

Everpresent
https://everpresent.com/

 # CATHI'S PICS (cont.)

Charter Oak Scanning
https://charteroakscanning.com/

Digital Memory Media
https://dmmem.com/

Personal Photo Organizer
Association of Personal Photo Organizers
www.appo.org

Roots Family History
https://rootsfamilyhistory.com/

Archival Boxes and Sleeves
Archival Methods
https://www.archivalmethods.com/

Children's Artwork
Keepy Me
https://keepy.me/

Table Top Lightbox
Shot Box
https://shotbox.me

04

Organizing Your Digital Photos

As I researched the simplest ways to help you with your digital photo collections, I came across a funny and totally accurate blog called, "My Travels in Digital Photo Organizing Hell" by Brad Feld.[9] He was three days into what he thought would be a one-day project and was giving up! Can you relate? Our biggest problem is our ability to take hundreds of photos and videos in an instant, from a hundred shots of a beautiful sunset to the pair of shoes we are thinking of buying. All too often, we skip the important step of deleting photos before we move on and take another hundred or so, all in just one day. I love the instant gratification of taking photos with my mobile phone, but I also miss the days when you could only take twenty-four photos at a time. I used to have a lot of self-discipline, and I was

careful to capture the best photo rather than every possible angle, pose, and subject.

As the days, weeks, and months progress, we lose track of where those photos are. Some are on our computer, iPads, iPhones, and camera cards; many more are stored on external hard drives, DVDs, and multiple cloud sites such as Dropbox, Picasa, Google Photos, Shutterfly, and other places we said yes to without even knowing it. It's no wonder we are overwhelmed! Surprisingly, the experts believe that the most photographed generation will have no pictures in ten years![10]

What will happen when our JPEGs, tweets, Facebook posts, MP3s, TIFFs, and GIFs are no longer readable? Or if the hardware to reach such files is hard to find, such as is the case today with VHS tapes and DVD drives? Almost all people have old digital cameras, SD cards, computers, and cell phones with photos and videos, all of which are getting harder and harder to read.

Here are three compelling reasons, by Caroline Gunter,[11] on why tackling this project sooner is more important than later.

Why This Matters

1. **Technology Fails and Disasters Happen**

 Consider this fact: statistically, you are more likely to lose your digital photos in a tech crash than your analog memories in a house fire or other natural disaster. It's no secret that hard drives fail. Lots of phones are stolen every day. Computers shut down, never to be powered again. In other words, your device is the most likely culprit when it comes to lost memories, not a natural disaster. Is it always accurate? Of course not. I don't believe that any disaster or accident

should be treated casually, so you'll need to consider the dangers your photos face.

2. **Intangible Memories Are Easier to Lose**

 Digital photos are easier to lose because they're not tangible and are usually scattered on different devices and across different platforms, and they don't come together as quickly. You just haven't looked at them enough to remember all of them, so they're easier to forget. You've never held them in your hand, and that makes a big difference. Many studies show we relate better to things we touch, so I have to believe that tangibility matters. It's much easier to forget about a few photos on an individual device than about a box of prints that you can physically see.

3. **A Digital System Makes Maintenance Easier**

 It's not uncommon for the photo organizing process to take a few weeks, and we often take hundreds of new photos while we're in the organizing mode. Without a system in place to deal with all the new digital photos, the to-do list keeps growing, and the project never ends. I like to think of it as a conveyor belt. The photos are just going to keep coming, so it's easier to quickly set up the conveyor belt to go in the right direction rather than having to deal with an amassing pile of files. Why add more to the mess? With a digital system in place, it's easier to maintain order."

STEPS TO ORGANIZATION

The following section breaks down digital photo organizing into fifteen steps with the goal to empower you to not neglect this critically important process.

STEP 1

IDENTIFY YOUR GOAL

*"Without goals and plans to reach them, you are like
a ship that has set sail with no destination."*

—Fitzhugh Dodson

My Goal

In order to be successful you have to have a goal. Take a few minutes and write down your goals, such as, "My goal is to have my digital photos in ONE location so I can find them easier." Or, "My goal is to locate the best photos from my daughter's first year of life so I can create a baby book."

> *"Without goals and plans to reach them, you are like a ship that has set sail with no destination."*
> —Fitzhugh Dodson

My Why

All too often we set goals without connecting with the "why". You'll have better success if you know the answers to these questions.

1. Why is this important?
2. How will I feel once this is complete?
3. What will I do when I hit a road block?

STEP 2

STICK WITH THE BASICS

There are many opinions, software programs, cloud solutions, and recommendations on the best way to manage your digital photos. As the founder of APPO, I have spoken with many companies and photo organizers about what are their best practices. At this time, my recommendation is to stick with the basics: use non-proprietary software, save your photos in multiple places, and be prepared to update your files on a regular basis. This approach will give you the most flexibility for the future because, as we know, technology is constantly changing, and you want to be prepared to take advantage of the future without losing all the work you have done. If you find yourself lost or needing additional assistance, refer to the Cathi's Pics section at the end of this chapter. I have listed all my favorite instructors, tutorials, and a link to finding a personal photo organizer to help.

> At this time, my recommendation is to stick with the basics: use non-proprietary software, save your photos in multiple places, and be prepared to update your files on a regular basis.

STEP 3

CREATE YOUR DIGITAL PHOTO HUB (DPH)

Your next and most important step is to create a digital photo hub to store every photo (and video) you take, including your digitized

prints and home movies. Your hub is the primary location for your entire memory collection and will be a master folder on your computer hard drive or on an external hard drive. When you have one central hub to store images from all your devices, you'll streamline your ability to manage them and reduce your risk of losing them. One hub makes it easy to back up your memory collection, and you will simplify your workflow significantly.

Here are a few things to consider when choosing the location for your DPH.

1. **Does your hub have the capacity to expand?**

 Chances are, you will continue to take photos and videos. If you locate your hub on an external hard drive or on your computer, then you need to ensure that you have ample storage space for your existing images and your future ones. High-resolution images and videos require a lot of space so choose wisely. Also, the price of hard drives continues to decrease. Currently you can easily purchase a one- or two-TB hard drive for between $55 and $150.

2. **Is your hub accessible and within your complete control at all times?**

 You should have access to your photos whenever you need to, which means your hub needs to be stored locally and not only online. The only exception to that rule is if you are living an entirely mobile life where you aren't tethered to a home computer. Mobile devices don't have the capacity to store your entire collection, making a cloud-based solution your only option. If you choose

an online service, pick a reputable established provider and read the fine print. Ask about privacy (protecting your image information), photo ownership, data stripping (removing your metadata or compressing your images), data mining (sharing your personal information for advertising purposes), and how you can retrieve your images if you decide to "break up" with your provider. Some online services make you pay to download your pictures. Buyer beware!

Finally, give your hub a name that makes it easy to locate. Smith Family Memories is a good example. My Pictures or Pictures is a little too vague.

STEP 4

CREATE A FOLDER STRUCTURE

Now that you've chosen a location for your digital photo hub, let's establish some structure. First, create a "To Organize" folder where you will copy all your photos before you move them into an easy-to-duplicate folder structure. (If you don't know how to create a folder on your computer, Google "create a folder" and follow the easy steps for either PC or Mac.) I recommend a folder structure that is scalable and easy to understand. For example, a dated folder structure is predictable and easy to maintain because today's images have dates embedded. Themed folders with no dated structure work better for old scanned photos that are hard to date. Use a numerical file name for your folders, which allows your computer to sort your folders in date order. Here is an example of a scalable folder structure that incorporates both:

Smith Family Photos
> 1980s
>> Celebrations
>> School
>> Vacations
> 1990s
> 2000–2006
> 2007
> 2008
>> 01 January
>> 02 February

Avoid overcomplicating your DPH with too many folders. Folders are for storing your photos rather than for organizing them.

Avoid overcomplicating your DPH with too many folders. Folders are for storing your photos rather than for organizing them.

One more step before you start collecting your images. Let's get a backup in place. Yes, that's right. Let's back up the chaos!

STEP 5

BACKUP

Whenever I talk about backing up, I like to reference Peter Krogh, a recognized photographer and pioneer of digital archiving. Krogh noted that there are two groups of people: those who've experienced a storage failure and those who will in the future. Thus, he created the 3-2-1 backup rule.

- Have at least **three copies of your data**.
- Store the copies on **two different media**.
- Keep **one backup copy off-site**.

We live in a world of rapidly changing technologies that continually demand bigger, better, and faster ways for storing and protecting your digital life. And while best practices for managing your digital assets evolve quickly, this has not been true for the 3-2-1 backup rule, which has withstood the test of time.

For years, organizations, businesses, and individuals have been using this method as a reliable strategy for backing up their digital files. Professional photographers use this method for protecting their large photo collections.

Let's break it down. We're going to talk specifically about backing up your memory collection (your digital photo hub), but this strategy applies to all your digital assets.

Three Copies of Your Digital Photo Hub

If you have your originals plus two more copies, for a total of three copies, you significantly reduce the odds of losing your data. You are creating a system with *triple redundancies*.

Stored on Two Different Media or Devices

When you store your originals on one device and a copy on a second device or media, that means you have immediate access to a backup if one of those devices fails. When your computer crashes or your EHD fails (and they will), your files can be restored from the other device. Storing these devices locally means you have full control and access at all times.

Store One Copy Off-Site

The third copy of your hub should be stored in a different location from your other two copies. If all three copies of your hub are located in your home, your precious memories are at risk if something unforeseen should happen to your home. Natural disasters, fires, floods, and theft are unexpected tragedies that can happen to anyone. We recommend a cloud-based backup or storage solution for your third location. If the cloud isn't an option, your third copy can be stored on another device or on optical discs (archival gold DVDs) and stored in a different location as far away from your home as possible.

> *"Backups that rely on humans never get done."*
>
> —Ben, the Newtown Nerd

"Backups that rely on humans never get done."
—Ben, the Newtown Nerd

The more you automate your backup strategy, the better! There are plenty of cloud backups that run automatically in the background of your computer, and your operating system has auto-backups that you can configure with your EHD.

If you already have a 3-2-1 backup strategy in place, give yourself a pat on the back. The 3-2-1 backup rule is one of the MOST important lessons in this book. I have witnessed too many tragedies in which people who have lost everything when a natural disaster happens say that what they are most upset about losing is their family photos. If the question of what you would save from a burning house intrigues you, you will enjoy the book by Foster Huntington called *The Burning House.*[12] What would you take with you? Foster collected answers to this telling question from thousands of responders all over the world to get to the heart of what

it is that people truly value and published them on his blog and eventually in a book. Family photo albums were often a part of what people want to save.

STEP 6

HUNT AND GATHER DIGITAL PHOTOS

Now you can proceed by collecting images from all the devices and locations you indicated during your hunt and gather inventory stage (see page 2). You may find it helpful to work in stages, one device at a time. Using the digital roundup form from cathinelson.com check off each device so you don't forget anything. .

As you bring each set of images into your "To Organize" folder, keep events or months together. For example, don't just dump 1,475 images from your camera roll into your folder. Use your smartphone's built-in app to identify groupings such as months, events, or collections. Once you have a group of photos in your "To Organize" folder, you want to give the images a quick review and remove all photos that don't need to be in your collection. Pictures of a receipt for business and the lunch photo you posted on Instagram are examples of the clutter you want to dispose of right away. Get rid of anything that you know for sure isn't a keeper.

STEP 7

NAMING YOUR PHOTOS WITH DATES

Next, create a folder and give the folder a name that represents the group of photos that will go into it. Your folder name should begin with a numeric sequence that represents the year first, followed

by the month. An example might be 2016-01 for January 2016. Inside that folder, you can create themed or event folders to break it down further if you want, depending on your volume of photos. The name of that folder should begin with a numeric sequence that represents the year followed by the month, followed by the day and the name of the event or theme.

Are you wondering why you need to use numbers instead of words for your file structure? Rachel LaCour Niesen, Steward of Stories and Founder of Save Family Photos, sums it up this way: "When it comes to organizing your photos, file numbers matter. By adopting a system and sticking to it, you guarantee that your photos will be easy to find, no matter how many years have passed. By using the date the photo was taken as part of the file name, you ensure you don't accidentally assign a photo a name that has already been giving to another photo."[13]

You may be asking, "But what about word associations that seem logical to creative types like me?" We checked in with one of the world's expert in digital asset management, Peter Krogh, and he says, "The most important trait of a file name is to be unique. It's hard to make them descriptive and yet unique."[14]

But there is good news for those of you who love words. Descriptive words are essential metadata and that is critically important. Just add the descriptive metadata after the numbers, and you will always be sure to find your photos.

STEP 8

LET'S TALK ABOUT METADATA

Your digital images contain information called metadata that helps identify valuable information about your photo. This information

is digitally attached to your image and stays with your photo. Your digital camera or smartphone is already embedding information such as dates and location data. What a timesaver!

Adding metadata to your images is the equivalent of writing information on the back of your printed photos (with a photo-safe pencil, of course). The more information the image contains, the richer the story.

When would you need to add or change the metadata? Remember when you got your first digital camera, and you didn't know how to set the date? All those images were created with the wrong date and will need correcting. If you have scanned photos, you'll need to add exact dates and additional information.

More importantly, you may want to add keywords or tags to make it easy to search for photos, or you might find it helpful to add ratings to identify your favorite images. And you'll want to add descriptions and captions that tell the story.

Some of these tasks can be performed with native tools on your operating system, but they lack the efficiency of photo-organizing software.

When you choose photo organizing software, you need to consider your comfort level with technology, your operating system, your time, and most importantly, your lifestyle. I'll share tips for finding the right software in Step 11.

Naming Old Photos

As you scan your printed photos from the past, it is likely you won't know when they were taken and it will be a guessing game. For example, Suzy looks like she is two years old her, so it might have been 1953. If you don't know, try and be as specific as possible. If the photo was taken in the summer, you can name it 1953-07-Suzy at two.jpg.

GET STARTED

Once you have completed these steps, it's time to move your newly organized folder out of the "To Organize" folder and into its rightful place in the main folder structure of your central hub.

Repeat until all of your photos are in your hub.

Let's Review Your Workflow

1. Move a group of images into your "To Organize" folder in your DPH.
2. Eliminate any photos you don't intend to keep.
3. Create a folder that represents this group of images, and give your folder a name beginning with a numeric sequence that identifies the date.
4. Create a subset of folders within that folder to represent events or themes within that folder.
5. Rename your image files with the numeric date followed by where, what, or who details.
6. Move your newly organized folder out of "To Organize" and into your main folder structure in your hub.
7. Repeat until you've transferred all your images into your hub.

Sounds easy, right? Easy yes; time-consuming for sure! This practice will eventually become your ongoing workflow and will become far less time-consuming once you have the bulk of your photos organized.

STEP 10

WHAT ABOUT DUPLICATES?

Your newly organized hub still has some potential problems. If you're like me, you have lots of duplicates. This happens if you accidentally duplicated a folder of photos and imported the same photos over and over. Also there are often "near duplicates"; these are images so similar they could be the same but were taken seconds apart. We can thank "burst mode" on cameras and smartphones for these treasures.

While it's easy enough to clean up a few duplicate images, if you have a lot of duplicates spread across multiple folders, the problem can be overwhelming. This is where some good software can make a big difference. There are a number of good-quality, free programs that can help you find and delete duplicate photos if those images are in JPEG and TIFF formats.

Once you find your duplicates, you can delete them or move them into a folder called "To Be Deleted" if you're commitment shy.

STEP 11

PHOTO ORGANIZING SOFTWARE

Before you move on to this step, I want you to pause and consider your readiness level. Some of you may be entirely satisfied at this stage of the organizing process. Your images are stored in your photo hub in your folder structure, and they have one automated backup in place. You can use the Search bar on your operating system to find a picture by name—remember, you added some

metadata that gave your photos some basic who, what, and where details when renamed or you can visually search your folders to find them.

Adding photo organizing software at this point has several benefits:

- Your photo-viewing experience is enhanced.
- You can add a deeper layer of organization with keywords or tags, smart albums, or collections.
- You can edit photos and apply filters.
- You can identify favorites with ratings.
- You can caption and add some descriptions.

The downside is that you may have a learning curve and financial investment to consider. Or you may run into some tech challenges, depending on the age of your operating system or the speed and connectivity of your internet.

If you're ready to proceed, you'll need to decide whether you want a desktop or a cloud-based photo organizer. There are pros and cons to either.

`TIP`

WHAT TO CONSIDER WHEN CHOOSING SOFTWARE

A desktop photo organizer is an app or software program that you download to your computer. The upside of this option is your ability to access and organize your photos without an internet connection. On the downside, your photos are only accessible in one location, unless you find a software program that syncs across multiple devices.

An online photo organizer resides in the cloud, and you upload your photo collection. The upside is you can access images from any device, easily share images and albums with others, and have a secondary backup in place by having a copy of your images off-site. On the downside, your accessibility and ease of use depend entirely on the quality and capacity of your internet connection.

STEP 12

CHOOSING AN ORGANIZING SOLUTION

When choosing an online or desktop photo organizing solution, look for providers who offer free trials. Run a test with a small group of photos so you can examine and compare before you commit.

Have you ever tried to Google "photo organizing software"? The results can be overwhelming and, at the very least, confusing. In addition to that, product changes continue to occur at a rapid pace, making it that much harder for you to make decisions.

> When choosing an online or desktop photo organizing solution, look for providers who offer free trials. Run a test with a small group of photos so you can examine and compare before you commit.

I'm going to equip you with information that will help you make the right choice for you and your memory collection and ease some of the fears you may feel about moving forward.

Desktop Photo Organizers

A desktop photo organizer is an app or software that you download and install on your computer.

- Some programs work directly with your folder structure (the hub you created) and apply changes directly to the photos in your folders.
- Some programs are proprietary and work with their internal database or catalog.

Your workflow will be easier if you choose a program that works with your folder structure. If you select a proprietary program, you have the added step of importing your photos from your hub into the program. There is no right or wrong; it's really about personal preference.

Here are some essential features you should expect from a desktop photo organizer:

- Is the program user-friendly, and does the company provide training tutorials and good customer service?
- Does the program use non-destructive editing (does it retain your original image)?
- Does the program adhere to IPTC standards[15] for applying metadata to your images? Yes, there are industry standards that you can learn more about at the IPTC.org website.
- Does the program have key features such as keywording, a rating system, simple or advanced editing, captioning or story-telling options, smart albums, etc.?
- Does the program offer a pleasant viewing experience or slide-show options?
- Will your program organize video formats?
- Is it easy for you to export and share images from the program?
- Is your metadata intact once you export your image(s)?

Online Photo Organizers

An online photo organizer resides in the cloud, and you upload some or all of your photos from your hub. In this scenario, you are sending a copy of your photos to your online provider and keeping your original images in your hub, which is stored locally on your computer or EHD. The distinct advantage of this option is that you automatically create a second backup of your photo collection that is stored off-site (in a different location than your home computer or EHD).

In addition to some of the features we outline in this section, here are others you should look for in an online photo organizer. Remember, when choosing an online provider to store and organize your precious photos, you are entrusting their safety to a company. Please do your research!

- Do you maintain ownership over your image? Read the fine print!
- Do you have complete control over your image privacy settings, and are they easy to understand?
- Does your provider protect your privacy regarding your personal information? FREE services mine your data for advertising purposes and share your information with third-party services.
- Does your provider keep your image metadata intact and in its original size? Some services compress your image and strip your metadata upon upload.

> Does your provider protect your privacy regarding your personal information? FREE services mine your data for advertising purposes and share your information with third-party services.

- Does your provider have any space limitations? Some services have a cap on how much space you have.
- Does your provider make it easy for you to retrieve or download your photos if you choose to discontinue the service? Some services charge you a fee or have download restrictions.
- Does the service offer keywording, ratings, and a folder or album organizing feature? How is this information captured in the metadata? Some providers have very limited organizing options and don't embed metadata in the image file upon download.
- Does your online provider have backup redundancies in place and high-level security?
- Does your provider offer a succession plan for your photos? If you pass away, will your family be able to access your account?

Some final thoughts before you choose photo organizing software. I've seen dozens of photo-organizing programs come and go, leaving a path of frustrated, unhappy users behind. The best way to avoid disappointment is to have an "exit strategy" in mind. If your favorite program changes or the company goes out of business, will your photos be trapped in their organizing structure? Will you have to redo all your organizing work? Or can you simply part ways with your data intact while you look for a new program. Another important consideration is the complexity of your program. All software has an ongoing learning curve as it improves and changes over time. If you chose a program like Photos for Mac, then you must fully commit yourself to learning how to use their program and maintaining your education as updates happen. If you don't have the time to learn a photo management program, then using a traditional file structure on your computer is

the easiest to maintain. I have surveyed photo organizers about their favorite choices and provide their recommendations in Cathi's Pics.

A Word About Apple

The photo management program Apple Photos comes installed on every Mac, iPhone, iPad, and iPod Touch. Introduced as iPhoto in 2002 and now known as Photos, millions of people have their photos stored in their iCloud account; integrated with their devices to provide a seamless ecosystem for photo creation, management and sharing. Of the over one trillion photos that will be taken worldwide, the majority will be taken on Apple iPhones and managed by Apple Photos. Photos offers unique challenges for many users and I recommend you try to stay up to date through online classes or working with a professional photo organizer.

STEP 13

EDIT AND DELETE

The last step in this process is for you to decide how you will define your favorite photos, your *A* photos, the ones you want to find quickly and easily in the future. Many software programs allow you to give your photos a rating or color. This makes it easy to find your favorite photos of Johnny's first birthday. While you are rating your photos, take the time to DELETE all those unwanted photos. The more diligent you are in deleting photos, the more manageable your collection will be in the future. Here are three guidelines to keep in mind:

1. Eliminate blurry photos.
2. Delete similar photos. You will often have sets of photos that are very similar. They might all be cute, but most must go. You will lose a lot of the impact of your photos if many of them look the same. I know that it can be hard to give up a photo that you like, but nobody needs five photos that are nearly the same.
3. Be ruthless and quick: try not to agonize for hours over every photo. You have to be somewhat unforgiving as you go through your photos. If you're having a really hard time giving up photos, use your rating system, such as five stars for definite keepers and four stars for maybes.

Not every photo you take is a winner, so don't let your best photos get buried.

SUMMARY

"The first rule of digital preservation is replication, redundancy, and planned migration," says Chris Martinez, the Manager of Media Archives and Digital Assets for the Missouri Historical Society. He goes on to say, "I think we are all going to become archivists and digital asset managers in the future". I know that can sound overwhelming, which is why the profession of professional photo organizers is growing. You can always hire someone to help you in the process. Photo organizers adhere to these three teaching options: I can come alongside of you, I can do it for you, or I can teach you to do it yourself. Don't hesitate to reach out for assistance.

> "The first rule of digital preservation is replication, redundancy, and planned migration,"

CATHI'S PICS

Forms

Digital Photo Roundup

Go to www.cathinelson.com to download the forms

Cloud Backup

Back Blaze

https://www.backblaze.com/

Duplicate Finders

Duplicate Cleaner (PC)

http://www.duplicatecleaner.com/

PhotoSweeper (MAC)

https://itunes.apple.com/us/app/photosweeper/id463362050?mt=12

Permanent Cloud Storage

Forever

https://www.forever.com/

Desktop Photo Organizing Software

Adobe Lightroom

http://www.adobe.com/products/photoshop-lightroom.html

Mylio

http://mylio.com/

Historian (*PC only*)

https://www.forever.com/historian

 CATHI'S PICS (cont.)

Online Photo Organizing

Flickr
https://www.flickr.com/

Forever
https://www.forever.com

Smug Mug
https://www.smugmug.com/

05

Organizing Your Home Movies

In this new era of recording our memories on our phone, Snapchat, and Instagram, many of us have neglected our film, tapes, and VCR recordings from the past. However, there is so much value in those old home movies, not only for you and your family, but also for the general public, as home movies provide a raw peek into the past. Learning to value your home movies is a vital step in preserving your visual memories.

Home movies are the most organic footage of the past. Peeling back the layers of our family histories may provide us with fresh perspectives. Rhonda Vigeant, vice president of marketing and home movie expert of Pro8mm, attests to this. She has built her career on helping families and celebrities alike access their old home movies and digitize their memories for future generations to enjoy. She says, "People are really fearful to look into the past.

It can force you to shift everything you believe about your family or your past relationships." Rhonda goes on to say, "We are acquiring new evidence. Home movies are like a time machine."[16] She has stood by her clients' sides as they see their childhood memories for the first time through adult eyes and watched as tears spilled down their cheeks. They had found something they didn't even know they were looking for.

Home movies no doubt have personal significance. However, as Vigeant says, "There are things to be unearthed in your movies that could appeal to a larger audience. What did [your family member] shoot in the world that has historical significance?"

So if you are under the impression that the only people who would care to view your home movies are your family, think again. Vigeant has come across footage of JFK, Elvis, and Jane Goodall, and some of this footage was then used by professional documentary filmmakers. Let it be noted that your family has been living their lives in the world and filming important things. People have this fundamental belief that their life doesn't matter, but to be honest, there's a huge interest, even in the simplest events we record such as birthday parties and barbecues.

<div align="center">

STEP 1

</div>

HOME MOVIE FORMATS YOU MIGHT FIND

There are many formats that people have used for amateur filmmaking and home movies.[17] This section lists the most common formats that you will find in a home movie archive, including your own.

9.5mm Film: Introduced in 1922, this is an amateur film format introduced by Pathé Frères as part of the Pathé Baby amateur film

system. It was used to provide inexpensive copies of commercially made films to home users and was popular in Europe.

16mm Film: It was introduced in 1923, and during the 1920s, the format was often referred to as substandard film by the professional industry. Initially, it was directed toward the amateur market. During World War II, it was used extensively for education and for TV production in countries where 35mm was too expensive.

Regular 8mm Film: It was introduced in 1932, and is also known as standard 8 or normal 8. Kodak introduced this format during the depression as a home movie format that was less expensive than 16mm. The film spools contain 16mm film with twice as many perforations along each edge.

Super 8mm Film: It was introduced in 1965 by Eastman Kodak and was more advanced than regular 8. It featured a better-quality image and was easier to use mainly due to a cartridge loading system.

In 1971, the first video cassette recorders were introduced including VHS and Betamax. This switch from film to magnetic tape created a mass market for VCRs and video recorders. By the 1980s, the price had come down enough to make them affordable for many families. If you are a baby boomer, it is likely you have a large collection of home movies on any of the following formats.

Tape Formats:

- **VHS:** Introduced by JVC in the 1970s.
- **Betamax:** Introduced by Sony in the 1970s.
- **8mm Video:** Introduced in the 1980s.
- **Hi8:** Introduced in the 1980s.
- **MiniDV:** Introduced in the 1990s.
- **DVD:** Introduced in the 1990s by Sony and Phillips.
- **Blu-ray Disc:** Introduced in the 2000s.

STEP 2

TIME IS CRUCIAL

Video Tapes Deteriorate!

Many people don't realize that those videotapes sitting in their drawers lose their magnetic signal over time, and the tape grows brittle, which means they can eventually break—even when sitting on a shelf!

It is accepted that tapes begin to degrade between ten and twenty-five years. A tape recorded in 1990 is now twenty-five years old.

It is accepted that tapes begin to degrade between ten and twenty-five years. A tape recorded in 1990 is now twenty-five years old.

STEP 3

HOW TO STORE YOUR HOME MOVIES

Now that I've convinced you of the value of home movies and listed what formats you might find, the next step is to preserve the physical copies of your home movies.

What to Store Them In: The goal is to digitize your film, yet you should always keep the original film for as long as you can. First, keep the home movies in an archival-safe box and away from the metal that may be encompassing it now.

Where to Store: Make sure you then store the film in a place where the temperature is regulated—around 62 degrees Fahrenheit—which means no attics, basements, or garages!

Your memories are important and valued. They deserve to be shared and seen by many as the years go by. The sooner you recognize this value and decide to preserve your film, the sooner you can save your memories.

STEP 4

WHAT TO LOOK FOR IN A HOME MOVIE CONVERSION SERVICE

Investigate how the work is done and who is doing it. Transfer services are abundant, and many of them use primitive equipment with minimally trained staff or film handlers. Many of these services use a modified projector with a video camera that tapes the image. They often don't have the tools to improve the picture and can damage the film; sometimes your film is sent out of the country.

Look for transfer services that use a sprocketless, capstan system designed specifically for scanning. This is the same type of equipment used by the film and TV industry. This kind of equipment has tools that offer color correction, dirt and scratch concealment, high resolution, and more. You'll pay more for high-end conversion, but it's worth it.

Ask your provider about the quality of their output. What is the highest resolution they can provide? Your goal is to have a high-resolution original as your master copy that will remain in your hub. You will edit and use derivatives to transfer to DVD or stream online (YouTube or Vimeo). If your provider **only** offers transfer to DVD or streaming to an online account, find another vendor. These files are highly compressed.

STEP 5

TRUE OR FALSE

Here are five common myths about home movies. Don't fall victim to these common misconceptions.

Myth #1: Transfers to DVD archive and preserve my home movies digitally.
Fact: A DVD is a low-quality copy of your original and will not preserve your images.

Myth #2: Old home movies shot on film are of an inferior quality compared to today's modern video camera.
Fact: The resolution and image quality of Super 8 and 8mm film is comparable to that of modern HD video. The reason the film transferred to DVD typically looks so bad is because of the low quality of the transfer and low resolution of the DVD medium.

Myth #3: You don't need to keep your original film once it is transferred.
Fact: Never throw way your original. It's your master and the best backup.

Myth #4: All home movie transfer services are the same.
Fact: There is a huge spectrum of services providers

Myth #5: The only option I have for my home movies is to transfer them to DVDs.
Fact: Today you should have your transfer given back to you as data (computer files) on a hard drive. This will give you the most options in editing and playback and sharing options.

STEP 6

EDITING YOUR FAMILY MOVIES

Like those undeveloped rolls of film, unedited, or "raw" video is worth saving, but it can be hard to enjoy two hours of your son's first steps when he is about to get married. The good news is you can turn hours of footage into a highlight reel of "wow" moments you, and your family will want to watch again and again. Fortunately, technology is making this easier and easier. You can either do this yourself or hire someone to do it for you. Here are ten tips if you are going to do it yourself:

1. Determine which program you have already installed on your computer or purchase one of the many products available.
2. Keep your movie short—three to five minutes is perfect.
3. Add music for more interesting viewing.
4. If the audio is great, leave it in; it is so much fun to hear voices.
5. Avoid fancy transitions.
6. Avoid crazy visual effects.
7. Mix video and photos for a more interesting look.
8. Give your movie a title.
9. Plan the story you want to tell.
10. Upload your movie to Facebook or YouTube for family and friends to enjoy.

SUMMARY

Your home movies are a slice of everyday life. They capture long-forgotten spontaneous laughter and conversations. Take the time to cherish these memories, and convert them for future generations to view as well.

CATHI'S PICS

Home Movie Conversion

Pro 8mm
https://www.pro8mm.com/

Everpresent
https://everpresent.com/

Forever
https://www.forever.com/

Fotobridge
http://www.fotobridge.com/

Movie Editing

Apple iMovie
https://www.apple.com/imovie/

Final Cut Pro
https://www.apple.com/final-cut-pro/

Windows MovieMaker
http://www.windows-movie-maker.org/

06

How to Maintain Your Photo Collection

Now that you have your photos organized into easy-to-find folders and themes, earmarked your favorites, and followed the 3-2-1 backup plan, there is still one more step to consider. How will you maintain your photo collection? This is the final critical step because you don't want to have to repeat all your efforts. I surveyed the photo organizers for this important section and here are their recommendations.

STEP 1

HAVE A PLAN

You will continue to take photos, and get busy; and chances are good you'll forget about the important task of managing your

collection if you don't take steps to prevent that now. Here is a list of best practices to ensure you are future-proofing your photo collection.

Create a Routine

Routines help form healthy habits. Choose a time each week or after each event to gather photos from your memory cards and smartphones and transport them into your "To Organize folder in your hub. Don't wait until your camera roll or memory card is full!

Schedule It In

Choose a regular time each month to sort your "to organize" folder, and then move those images into the folder structure in your hub. Flag or rate your favorite photos from that month to have printed or placed into an album. Check to make sure your backup systems are working, or perform a manual backup. Add this important task to your calendar so you don't forget!

> When it's time to change your clocks, it's time to run a diagnostic on your backup systems and external hard drives. Most EHDs come with a utility that allows you to run a performance scan.

Spring Ahead, Fall Forward

When it's time to change your clocks, it's time to run a diagnostic on your backup systems and external hard drives. Most EHDs come with a utility that allows you to run a performance scan.

STEP 2

CREATE A PRIVATE FAMILY ARCHIVE!

Online archives provide a living timeline of your family history and make it easy for you to collaborate and share with family members.

The way we share photos and tell our story has changed significantly in the last twenty years, thanks to technology, the internet, and social media.

We can use social platforms such as Facebook or Instagram to share photos and stories. We can dig into the past through sites like Ancestry.com, and we can store, organize, and share large collections of images through sites such as Flickr, Forever, Smug Mug, Google Photos, and Dropbox.

Fortunately, some solutions offer a private, secure place to archive your images, videos, audios, and documents. When family members contribute photos and details, you begin to build a family archive that is rich in historical information.

TIPS FOR SUCCESS

Be Selective

A family archive is a carefully constructed online album, not a dumping ground for all your photos. Choose pictures and videos that best tell the story, and leave the rest in your digital photo hub.

Be Descriptive

Imagine future generations viewing your archive. Is there enough information in the photo descriptions? Have you mentioned full

names (and maiden names) to help piece together your family tree? Have you told important family stories?

Involve Others

You can't remember everything! Engage as many family members as you can to help add family history to your narrative.

Make Good Choices

The internet is filled with free and paid-for services, so do your homework. An online archive can become a family heirloom that succeeds you, so choose wisely. Here are a few things to look for:

- Is the archive easy to set up and manage? Is it user-friendly, and does the provider offer tutorials or training?
- Do you maintain ownership over your images? Read the fine print!
- Do you have complete control over your image privacy settings, and are they easy to understand?
- Does the provider protect your privacy regarding your personal info? FREE services mine your data for advertising purposes and share your information with third-party services.
- Does the provider keep your image metadata intact and in its original size? Some services compress your image and strip your metadata upon upload.
- Does your provider have any space limitations? Some services have a cap on how much space you have.
- Does your provider make it easy for you to retrieve or download your photos if you choose to discontinue the service? Some services charge you a fee or have download restrictions.

- Does the service offer keywording, ratings, and a folder- or album-organizing feature, and how is this information captured in the metadata? Some providers have very limited organizing options and don't embed metadata in the image file upon download.
- Does your online provider have backup redundancies in place and high-level security?
- Does your provider offer a succession plan for your photos? If you pass away, will your family be able to access your account?

STEP 3

CHANGE IS THE NEW NORMAL

One last word of advice as you manage your digital photo collection—change is the new normal. Getting everything organized and backed up isn't a "set it and forget it" strategy. You have to maintain your collection and recognize that technology and companies change quickly. Sometimes companies go out of business or update their software with no warning. When you've got several copies of your photo hub, you will be protected from losing all the work you've done. If you want to explore this topic deeper, I recommended reading *The DAM Book; Digital Asset Management for Photographers* by Peter Krogh.

I also recommend exploring the International Press Telecommunications Council (IPTC) website. This organization sets the standards for the industry, and their guidelines are the most widely used because of their universal acceptance among photographers, distributors, news organizations, archivists, and developers. They

also maintain a list of software programs that support their metadata recommendations.

Now it's time for the reason I wrote this book in the first place—it's time to share and enjoy your family photos, videos, memorabilia, and stories. This last chapter will provide you with lots of creative ideas to bring your memories to life.

CATHI'S PICS

Family Photo Archive

Smug Mug
https://www.smugmug.com/

Forever
https://www.forever.com/

Ancestry
https://www.ancestry.com/

Zenfolio
https://en.zenfolio.com/product/features

Online Book

The DAM Book
http://thedambook.com/the-dam-book/

07
Celebrate and Share Your Family Photos

I f you have made it to this chapter, congratulations! In the opening of this book, I promised you would never regret this journey of uncovering lost memories in your photo collection. I knew intuitively, when I first started my business, that although I called myself a photo organizer, I was really a photo storyteller. I quickly learned that it was impossible to help someone create a meaningful photo album for a high-school graduate or video montage for a rehearsal dinner if I couldn't find the best 100 to 200 photos. That is why I always say, "Photo organizing is a means to an end; the real goal is to share and tell a slice of your life." So now that we have arrived at this chapter, the real

> "Photo organizing is a means to an end and the real goal is to share and tell a slice of your life."

fun begins. This is a chapter of ideas and suggestions of fun and creative ways you can now share your photos, videos, and memorabilia. This will result in my fulfilling my promise that you won't regret the time you have taken because now you get to share the results of all your hard work. Even if the only person who ever looks at the photos is you, it is a worthwhile and important part of celebrating your life with all its ups and downs.

Why Is This Important?

Telling your story is about so much more than posting photos and seeing how many likes you get. It's more than a folder structure neatly organized. Your complete family story shares your values, your beliefs, your contributions to the world around you, and your hopes and dreams. It connects the past to the present and inspires future generations.

The New York Times published an excellent article in 2013 by Bruce Feiler called, "The Stories that Bind Us."[18] He reports that "families who refine and retell a unifying narrative about their positive moments and resilience during difficult times produce children who consistently show more self-confidence." Knowing the answers to questions such as "Do you know where your parents grew up? Do you know the story of your birth? Do you know of an illness or something difficult your family has experienced?" were the best predictor of a child's mental health and happiness.

> "Families who refine and retell a unifying narrative about their positive moments and resilience during difficult times produce children who consistently show more self-confidence."

Family Stories Build Self-Esteem!

The more children knew about their family's history, the stronger the children's sense of control over their lives, the higher their self-esteem and the more successfully they believed their families functioned. We feel this is true for children AND adults!

Your family photos and videos hold the key to your family narrative and serve a profound purpose. With your newly organized memory collection, you have the ability to curate your family stories into photobooks, wall displays, video montages, online photo albums, and so much more.

Your Story Matters

If you are thinking no one is interested in seeing your photos, this project isn't for others. It's for you! What do *you* care about? Did you uncover photos of your pets or flowers in your garden? Are you without an extended family and wonder if anyone is interested in your photo collection? There is tremendous research on the value of remembering; think of this as a project for you. This is your opportunity to create something that brings you joy.

IDEA 1

CREATE PHOTO ALBUMS

There is a fun saying I like to tell folks: if Moses was given the ten commandments on a flash drive, they wouldn't exist because of changing technology. The best backup is still a paper archive that can survive centuries of neglect.

> The best backup is still a paper archive that can survive centuries of neglect.

Digital archives require careful management if they are to last more than a few years. When you create physical photo albums or photobooks, you increase the odds that your family story and precious memories will succeed you!

Printed photobooks, scrapbooks, and photo albums don't rely on technology to be enjoyed. You don't need an internet connection, and you won't need to migrate them to a new format to view them fifty years from now. When you combine images and words into a documentary-like narrative, you are creating a historical record for future generations with stories that you can celebrate and enjoy today.

The market is filled with an abundance of album choices to suit your needs. Scrapbook albums have the added benefit of providing you with a creative outlet. Pocket-page albums make it easy to assemble an album quickly if time is an issue for you. Digital photobooks make it easy and efficient to use online tools and templates to auto populate a photobook while you focus on the words that tell your story.

TIPS FOR SUCCESS

Quality matters! Choose products that have archive-quality or photo-safe materials to ensure the longevity of your albums. Select album options that suit your lifestyle, budget, and time considerations. Completion is the most important goal. If you don't enjoy sitting at the computer to create a photobook, it will quickly become a chore. If you are frustrated by the creative process of assembling a scrapbook, it will slow you down.

Themes, rather than chronology, will make it easier to curate a story. Favorite topics include vacations, sports, family traditions, or events such as weddings, anniversaries, and birthdays.

Choose the themes that are most common in your family, and combine them into an album that spans over time. If you prefer a chronological timeline, choose ten to fifteen photos per month for an annual Family Yearbook. Or choose ten to twenty photos per year for a Celebration of Life. The greatest reward for your effort will be the joy on the faces of your loved ones enjoying your albums!

IDEA 2

VIDEO SLIDESHOWS AND MONTAGES

When you combine photos, videos, oral narratives, and music into a slideshow or montage, you create a living album filled with emotion and fun.

Video slideshows or montages are a fun way to bring photos and videos together to create a compelling and emotional story. When you add music or oral narratives or both, the result is a living album filled with movement and sound that triggers your senses.

Slideshows are a great option for family gatherings, special events, and celebrations. And they can be a fun option to enjoy on family movie night. Popcorn, PJs, and precious family memories—can it get any better than that?

There are online solutions that make it easy for you to create slideshows by uploading photos and video clips. Some online services offer royalty-free music and templates that make it simple for you to render a studio-quality production in a few clicks. If you prefer a hands-on approach, iMovie (Mac) or MovieMaker (PC) may work for you, or you can invest in software solutions that come with more tools, effects, and support.

TIPS FOR SUCCESS

The Shorter, the Better!

Attention spans aren't what they used to be, so keep your slideshow to less than ten minutes, or even shorter depending on the event. Use a combination of short video clips (ten to fifteen seconds long) and a variety of still photos to create movement.

- Keep the photos moving along at a quick pace. The difference between ten seconds per photo and five seconds is huge
- Music can make or break your video! Music should match the tone and theme of your photos. Choose royalty-free music especially if you plan to share your completed slideshow online.
- Add an oral narrative. Record Grandpa narrating the story of his mom and dad and layer this audio with the photos and background music. Please pass the Kleenex!
- Don't go crazy with transitions. Keep it straightforward and consistent for the best viewing pleasure. The Ken Burns effect is still a classic and dramatic way to view slideshows.
- Add your completed slideshow to your digital photo hub and back it up.

IDEA 3

WALL GALLERIES

Are you looking for instant gratification while you work on that family archive or photo album? Decorate your home with the people you love! While you organize photos, you'll come across pictures that are too good to keep hidden. Look for frame-worthy

images that you can display on walls or turn into photo gifts for others. Here are a few ideas:

Gallery Wall: Choose a collection of frames that suit your decor, and create a feature wall in your home. This is an excellent way to showcase heritage photos, family weddings, a special event or vacation, or the growth of your kids.

Canvas Prints: Canvas is lovely for its art-like quality and makes a great statement piece. Look for unique fun photos that evoke conversation and storytelling.

IDEA 4

DIGITAL DISPLAYS

This is an excellent choice for technology-challenged family members. This plug-and-play way to display image slideshows is perfect for people who want a quick, easy way to showcase their memories.

IDEA 5

PHOTO PRODUCTS

There are many ways to take your favorite photos and turn them into photo gifts for you or someone special. You can choose from photo blankets, wall calendars, mugs, puzzles, ornaments, smartphone covers, and stationery, to name a few.

Photo Gift Suggestions for All Ages and Stages of Life

If you are still feeling stuck, this next section will give you ideas of what to do at different ages and stages of life.

BABIES AND TODDLERS

ABC Photobook: Children love seeing photos of family members and items they recognize. You can quickly go through your photo collection and chose two to three photos for each letter of the alphabet. For example, *A* is for Aunt Jennifer, *N* is for nap time, and *D* is for your dog. You can find a lot of ideas online, but this personal book will easily become your child's favorite nighttime story.

Home Movies: In addition to your children's favorite Disney movie on your iPad or iPhone, download family home movies and video clips. Next time you are with Grandma or Grandpa, record them reading a story and allow your children to watch that over and over again.

Photo Wall: In your child's bedroom, create a family photo wall of framed family photos.

SCHOOL-AGE CHILDREN

School Days Photobook: Every year, I wrote my children a letter on their first day of school and placed it in their school days photobook that started with preschool. It was a book that I added a few photos and memorabilia to each school year. They still like to go back and look at the photos, especially when they meet someone in town and realize they went to school with them many years ago.

Displaying Artwork: There are hundreds of ideas on Pinterest, but a few of my favorite include hanging a wire and using clothing pins to hang the changing artwork, as well as setting up a large cork board that gives you the opportunity to update with new work each month.

Pillowcase or Blanket: Today's technology means you can add photos to anything. Create a photo blanket with pictures of your children's loved ones, and then wrap them in love every night.

TEENS AND YOUNG ADULTS

My Wish for You: This is the age that your children are seeking to separate and create their own identity. They no longer want their photo taken by you. Now is the time to create a photobook or video that allows you to share your hopes and dreams for your emerging young adult. Some folks use words from a favorite song or poem and choose photos to match the lyrics. Your child may not thank you right away for this book, but it can become a treasured keepsake for them to visit when the stress of life wears them down.

Online Photo Gallery: There are many online websites that you can access and then encourage your kids to upload their favorite photos so everyone can see a copy of their photos. These galleries can serve many functions including being a backup and permanent archive. Don't rely on Facebook and Instagram as the place to save your favorite family memories.

Video Interview: Young adults are forming their opinions and ideas, and capturing those thoughts are not just for "older folks." We are living in the midst of history, and a great gift can be asking your young adult to share their perspective about what is happening today and their hopes and dreams for their future.

PARENTS AND GRANDPARENTS

Digital Photo Frame: These picture frames display digital photos without the need of a computer or printer. Some may even play videos as well as display photographs. Thanks to a new generation

of cloud-based, wireless, digital photo frames, it's possible to share photos without complicated wires or USB transfers. You can upload photos while on vacation, and they will show up on the digital photo frame in real time.

Family Legacy Video: Sharing the history of your family is one of the most generous and loving gifts you can give. Creating your life stories on video has a powerful impact today, and it's also one of the most special heirlooms to share forever with future generations. Seeing and hearing loved ones telling stories—laughing, even crying, and passing on life lessons and meaningful traditions—is an important reminder of the value of family and preserving our legacies. You can do this yourself or hire a professional to assist you.

Video or Photobook Inventory: Break out your video camera or camera, and gather your family and the possessions you care about. Shoot each item, describe what it is, and share the memories and stories it evokes. With a little editing, the result will be a cool visual record to pass along to future generations.

JUST FOR YOU

My Favorite Things: Make a list of your favorite things such as books, hobbies, places, and pastimes and take a photo and create a story of your favorite things. I did this for myself and included a photo of my first cup of coffee in the morning, a walk with my doggies, and a pile of books I love.

SUMMARY

I hope this chapter has helped you think about your photos in a new way. As you go forward and continue snapping photos, take

the time to think about what the photos represent and all the fun ways you can share your story. If you find yourself stuck along the way, reach out to a personal photo organizer. They are passionate, committed professionals waiting to assist you on this journey.

 CATHI'S PICS

Digital Photobooks
Picaboo
https://www.picaboo.com/

Blurb
http://www.blurb.com/

Mpix
https://www.mpix.com/

Custom Photobook Design
Books of Life
https://www.yourbooksoflife.com/

Personal Photo Organizer
Association of Personal Photo Organizers
www.appo.org

Video Montages
Pro Show
http://www.photodex.com/proshow

Animoto
https://animoto.com/

 # CATHI'S PICS (cont.)

SmileBox
http://www.smilebox.com/

Custom Framing
Framebridge
https://www.framebridge.com/

Pictli
https://www.pictli.com/#/

Traditional Photo Albums
Creative Memories
https://www.creativememories.com/

Kolo
https://www.kolo.com/

Digital Scrapbooking Software
Artisan
https://www.forever.com/artisan

Project Life
https://beckyhiggins.com/

Heritage Makers
https://www.heritagemakers.com/

 ## CATHI'S PICS (cont.)

Digital Photo Frames

Nix Play

https://www.nixplay.com/

Help with Digital, Printed Photo Organizing, Gifts, Photobooks, Legacy Videos

Association of Personal Photo Organizers

www.appo.org

08
Conclusion

"The very act of story-telling, of arranging memory and
invention according to the structure of the narrative, is
by definition holy. We tell stories because we can't help it.
We tell stories because we love to entertain and hope to edify.
We tell stories because they fill the silence death imposes.
We tell stories because they save us."

—James Carroll

Congratulations on recognizing the importance of organizing your photos and seeking guidance. It can feel like a monumental task, but don't lose sight that this is important and meaningful work. You are the keeper of your family's memories and the teller of family stories.

> You are the keeper of your family's memories and the teller of family stories.

While you are working on this project, history keeps unfolding: babies are born, children grow taller, vacations come and go, kittens become cats, loved ones pass away. Your family's story is a thread in a larger tapestry. Ideally you will come to view this project as not just organizing photos from the past but as a new way of ensuring future photos are also enjoyed and shared.

Here is one final story that I hope showcases the heart of this book.

What do you see when you look at this photo?

An elderly woman? I see the women we affectionately called Aunt Izzie, a German immigrant who came to the US after World War II. She came here as an indentured servant, working for a family that was cruel to her. It took her four years to pay for her

freedom, and then she married my grandfather. Listening to her stories of surviving the war, the hunger, the fear and the losses, all impacted me deeply as a young child and likely contributed to my lifelong fascination with stories and photos. It is important to me that my children—and someday their children's children—know these stories.

I know most of your photos and stories aren't about war heroes and tragic losses. Neither are mine. They are mostly a collection of extraordinary and ordinary moments of a life well lived. Yet contained in those photos are our stories, which are—just as James Carroll says—*holy*.

Thank you for joining me on this journey and visit me at www.CathiNelson.com to leave a note or share a photo and story or two of your own.

 ## CATHI'S PICS

Save Family Photos
https://www.savefamilyphotos.com/

Cathi Nelson
www.CathiNelson.com

A Slice of Life: Essays About Photo Projects

As I began the process of writing a book about photo organizing, I kept thinking that if I only included how-to guidelines I'd be missing the emotions, joys, frustrations, and healing stories that are what make a photo-organizing career so powerful and meaningful. I interviewed individuals and photo organizers about projects they have worked on across various themes from adoption to a 9/11 Memorial project. These are their stories in their words. I recommend reading these when you get stuck or need encouragement to keep going. It is a privilege and honor to journey alongside others as they reveal parts of their family stories.

One Family's Story: Surviving the Holocaust by Sally Rabinowitz

I've always loved photographs. Not of me—of other people. My mother, a well-known photographer, Jill Enfield, is the daughter and granddaughter of photographers. Her dad and grandfather even had camera stores in Florida that first opened in 1939. Before that, they owned camera stores in Frankfurt, Germany. I often look through old family photographs that are rich with a bygone era, not only of my own family but also of life in general. I am thankful to hail from a long line of family members who recorded our lives. We have always had darkrooms in our homes in New York City or upstate New York in the Hudson Valley. One memory that is always nearby and makes me smile are times when my mother allowed me to help her in her darkroom.

My father was a history buff and that rubbed off on me also. We lived in New York City and often visited the Metropolitan Museum of Art, where the exhibit of Egyptian mummies and artifacts never failed to fascinate me. I was much more interested in the past than the future. I was particularly interested in our family history. Family members knew bits and pieces, but, in between those pieces, were large gaps. You see, my family was a part of the Holocaust.

Photographs and history and family began to merge when Rabbi Frank Dabbo Smith in London contacted my mother. He was doing his PhD dissertation on Ernst Leitz II, head of the Leica Camera company who helped hundreds of Jews escape Nazi Germany. My maternal grandfather and his parents were among those he saved. The information that he shared with my mother about her family sent me off on a mission to learn more.

My mother and I, and our cameras, first went to London. My grandparents had settled there with Mr. Leitz's help, and family members still lived there. They had photographs, an unimaginable number of photographs. I can't describe what it was like to see these people, long gone, to look into their faces for traces of my mother or me and imagine what it was like for them needing to leave their lives in Germany behind.

We went on to Germany with Frank. He knew many people there, and those people had more photographs for us. We began by looking at strangers. "Who's this, and who's this?" By the time our pilgrimage ended, they were strangers no longer. We knew their names, how they were related, how they lived, and how they died. Photographs bring people to life, unlike any ancestral tree can do with its dates and connecting lines.

Such a mixture of emotions. Excitement at finding answers to the puzzle of my family history. Warmed by the memories that others had of my family and that those people thought enough of them to keep the photographs. And now we could meet them—face to face, so to speak.

Frankfurt was difficult. The city where my ancestors lived. I felt alienated, as though I didn't belong there, even though there is no trace of anti-Semitism in Frankfurt today. My family's home was still standing.

I went to Buchenwald, the concentration camp where my great-grandfather and his brother were taken. I felt such fear that I could barely walk. I talked with the archivists and sobbed uncontrollably. Until then, I had been able to interview and take notes and photographs without incident. I retreated to my camera. It was easier to look through the lens with an artist's eye than look at the scene of unspeakable horror with the eyes of a descendant. I felt comforted by the camera. I was recording these scenes for others.

I keep everything now. Letters, postcards, and, of course, photos. Computers are great, but they crash. I have to have hard copies. What an irreplaceable loss it would be if I did not have the generations of photos to pass on when I have children.

In a high school history class, we learned a quote, "We learn from history that we learn nothing about history," (Georg Hegel, German philosopher). That quote touched me, and I've always remembered it. We see that we learn nothing when we

> "We learn from history that we learn nothing about history."

see how genocide happens, how it follows the exact same patterns leading up to it. Then we look back and think, "I could have, should have, would have..."

History lives in the stories that are told through photographs.

About Sally

Sally Rabinowitz is a recent college graduate and, unlike her contemporaries, has less interest in those omnipresent smartphone snapshots that get posted and deleted with equal speed. Her connection with her family, her photography, and her love of history converged in her video: "One Family's Story: Surviving the Holocaust," which you can find on YouTube. Sally has been flown to a number of museums and religious venues around the US to show her video and remind the audience members to take time to learn from their living elders what their life was like in their youth. In her lectures, she reminds people that the Holocaust is not just a historical moment in time but is a tragedy that repeats itself again and again all around the world.

The Accidental Photo Organizer
by Ann Monteith

When I found the photographs, I felt like Alice who fell down the rabbit hole. It was the biggest shock of my life. Why would I not know about the photographs, you ask.

I was an Army brat. We moved thirty times before I got married. If that sounds impossible, sometimes we lived in temporary housing while waiting for our permanent (so to speak) house. When you move that many times, you don't have time to set up a real household. It seems like no sooner do you unpack and you're packing back up again. So that's one reason. The other reason is that I have no recollection of my father taking a lot of photos. He must have been pretty quiet about it when I was younger. Therefore, there was no reason that I would know there were photos somewhere out there.

People usually need to "hunt and gather" their photographs. I came upon mine accidentally. I needed another guest room, so I went to a room that only the kids had used years ago. I was looking around and opened a closet. There was a very large, very heavy box filled with files. In the files were photographs.

I don't know how long they had been there. When my father died about ten years ago, things were chaotic. I was President of the Professional Photographers of America, and he was in a nursing home for the final six months of his life. He had remarried after my mother died, so his belongings were in the home that he and his wife shared. After he died, a file cabinet was brought into our garage by someone—I have no idea who put it here. As busy as I was, I never looked inside of it. I imagine that the box must have appeared at the same time and somehow made its way to that closet.

The first photos I saw were taken when my father was stationed in Japan. My memory of Japan is strong. The photos confirmed my memories. There was the art nouveau furniture that I remembered. There was my nanny, Marie. I was transported back to that time and place. I thought, "What a shame that I don't have photos of the rest of my life growing up!" And then I found the rest of my life. My father had recorded my life!

He also recorded images of post-war Japan. There were photos of Yokohama and Hiroshima. The thing that astounded me, besides his mastery of the camera, is that the photos are exactly the kind of thing that I do when I'm working on street photography in Ireland.

Once I discovered the box, I thought about the file cabinet. There were my mother's scrapbooks about her early upbringing in Arkansas. Now I had a whole secondary level of photographs. I began piecing the stories together. Some of them left me sitting there bawling because they are so powerful.

I remember my grandmother (my mother's mother). I spent a great deal of time with her. She was the heart of the family, an amazing woman who arrived in Arkansas in a covered wagon and homesteaded. I went back there in the 1990s and have many photos from that time.

Among the photos that I found in my mother's scrapbooks was one of the most poignant of all—my aunt, Mary, whom I never knew because she had died of complications in childbirth. Her husband died within two days—they say from a broken heart. Their son Buck lived with my grandmother and became my mother's "other brother." There were photos of my mother's three brothers and the fourth one, Buck. Buck was killed in World War II when he was twenty-two years old. Two weeks before he died, he had written to my mother and mentioned me. How great it was to

see me. I was a year old at that time. My mother saved letters as well as photographs.

My grandmother always said I was so much like Mary, because I did a lot of things with my hands. She said Mary could always make something out of nothing. She sure did! I have a photo that Mary took of my other aunt with a pinhole camera that she made. Cardboard and a piece of film! Lord only knows how she got the thing printed. In the background is a quilt that she made. I'm a quilter also. It's been a tremendously emotional journey. I'm not usually emotional, but this is all such a gift, and the gratitude I feel is extraordinary.

I want to share all that I've learned about my father and mother and many of the other relatives in the photos. I want my kids to know where they come from because they come from very strong people. That's one of the great gifts of all of this. And so the narrative is extremely important to me. I'd be a lot farther along with organizing the photographs, except I've been creating the narrative at the same time. The photos and the narrative are one to me. I couldn't have done one without the other.

> I want to share all that I've learned about my father and mother and many of the other relatives in the photos. I want my kids to know where they come from because they come from very strong people. That's one of the great gifts of all of this.

One of the things that I've been struggling with is how to tell the story without boring my children senseless. At the same time, I want to tell these stories in bits and pieces so that they can digest them and maybe then they'll want more.

As an English teacher, I taught that you have to know how to engage your readers. Who are my readers? My fifteen-year-old

grandson. He's the one that I'm thinking about as I weave my tale of our family history.

About Ann

Ann Monteith has been a professional portrait photographer for thirty years. She is past President of the Professional Photographers of America; an author of books on photography and the photography business; and a former educator in photo journalism, English composition, and marketing.

Memories of a Life Well Lived
by Donna Pullan

Everyone has a story and every story matters. I love helping people tell their stories using photos and memorabilia. There is nothing more meaningful to family members than passing these treasures along.

I worked with a family who had thousands of photographs: years and years of photos of a family with four children and very active, on-the-go lives. We began organizing photos of their son, who had lost his life in the World Trade Center on 9/11. They wanted his story told—photo proof that he had lived a life filled with family and friends, achievement, fun, and laughter. We have birth certificates and death certificates, but photos show proof that we really lived.

They had several high-end leather albums with his name embossed on the covers, but they could never bring themselves to sort through all the photos and choose the most special ones to preserve. That's where I came in.

You need to be prepared for what an emotional process any sort of celebration of life or tribute book can be. I spent many hours with the family (primarily the wife). Seeing and hearing her pain when she told me the stories associated with the photos of her son was deeply personal and touching. There were days when she

> We began organizing photos of their son, who had lost his life in the World Trade Center on 9/11. They wanted his story told—photo proof that he had lived a life filled with family and friends, achievement, fun, and laughter. We have birth certificates and death certificates, but photos show proof that we really lived.

couldn't do it. There were times that I got emotional and cried. I would have to step away for a couple of hours or a couple of days.

When working with a tragedy such as the loss of a child, we first determine what the message is to be. This family wanted a tribute book. From that, I developed a project management outline of how we would proceed. The outline held it all together. After a couple of initial sorting sessions with the client, I saw a pattern develop and could start grouping the photos by category.

The photos don't have to be in chronological order. I had pages of school pictures from elementary school through college, and pages of his athletic life. It's not about choosing the best photo. It's about what part of the story each photo tells. Everyday moments speak better than posed portraits: reading to his little brother, eating popcorn in front of the TV, playing with his cat.

It was a healing process for the family. I needed their input, so we talked a lot about their son and the stories of his life. They got to tell their son's story to someone new. I think the whole sorting, organizing, scanning, and book process helped them also. They saw those mounds of photos organized and preserved. They had two stunning books that highlighted what a special young man their son was and how fortunate he was to have lived a life that was filled with so much love, laughter, and friendship. They accomplished this tribute to their son that they had wanted to do for so long. They have a cohesive, meaningful story to share with others. I hope this gave them just a little bit of closure.

About Donna

Donna Pullan is the owner of Legacy Photos and Stories, a boutique legacy preservation service that helps families organize, preserve, and share their photos, stories, and memories.

The Gift of Memories
by Jodi Bondy

I dabbled in photo-organizing for at least fifteen years but had no real purpose in mind until two years ago when my dad was diagnosed with cancer. As he was going through chemo and radiation, we had a lot of downtime. We had to travel to the treatment centers, and we stayed four days each time. There were a lot of hours to fill, and I hit on the best way to fill them.

Six or seven years before, I had given my parents four scrapbooks of photographs. I asked them to add the stories behind the photos during those winter months when they were snowbound. Well, it never got done.

Now was the perfect time to do it. I had lost my grandparents and aunts and uncles and realized that I had heard a lot of family stories while I was growing up, but, you know kids, I wasn't paying attention. After all, there wasn't going to be a test! And the day came when their stories were forever lost. Now, I wanted to pass the family legacies on to my children and grandchildren, and I needed to start scrambling to grab as many of the stories as I could, when I could.

The scrapbooks helped pass the time while Dad was undergoing treatment. Dad and I went through them. I used the voice recorder on my phone to make sure that I got every word. He told stories associated with the photos. I asked questions: "Okay, but remind me now, where is this?" and "How did we do this?" and "What is this?"

I made notes also, but I haven't yet transcribed the notes or the recordings. The important thing is that I have stories that will patch up some holes in our family history. We didn't get through all the scrapbooks, but I learned things from my dad's early days:

when he went into the army, the people that he went in with, where he was, what he did.

When my dad was eighteen, he and a buddy drove to Florida, pulling their boat behind the car and sleeping in the boat at rest areas. Then from Florida, they went to Cuba! When I was young, I'd wonder why my dad didn't let me do some things I wanted to do. Now I knew—because he had done them and knew the dangers!

What I loved best was when my dad was looking at the photos and telling me the stories of his life, he was at his most vibrant. He told me about when he started working and the jobs he had. He remembered his bosses' names from back in the 1940s and 1950s. He remembered every detail. He didn't remember we'd just had lunch. But as soon as I pulled out the scrapbooks, he snapped right back and knew every detail.

In those final weeks, rather than sit with him and be sad and anticipate what was coming, I pulled out the scrapbooks. He would liven up, talk to us in a semi-normal way, and be a part of the family.

Gathering these stories enabled me to see who I am, where I came from, and why I am the way I am. I'll pass those things on to my kids. Now that I have them, I can't lose them. People's photos end up in boxes in antique

stores or junk shops, and their stories will not live on. I don't want my pictures to end up like that.

There were times that I felt bad for my mother. So much of the focus was on Dad. My mom grew up in Mississippi. Her family didn't have a lot of money, and they didn't take many photographs. We have so many pictures of my dad growing up and of his family, and we don't have that for my mom. Was she envious or sad that she didn't have those kinds of memories to share? No, she was glad to see me spending quality time with my dad. He had worked so much when I was growing up. We'd go camping and do some other things together, but mostly he worked. It helped my mother to see us together and enjoying each other.

Those times helped me also. When I finish the book, it will help me even more. There will be days that I'll need it to remember something. There will be days I'll look through it to be proud, once again, of my dad's life, and I'll think back to those treasured days we spent together.

For those who want to assemble photos and their stories, I found it's best to do it in little chunks. Trying to do it all at once can be exhausting.

Also, accept that there are things you may never know, things your loved ones don't care to talk about. You can't let that get in your way. Take it slow and easy and get as much as you can. Even if you don't get everything you want, you'll have more than you started with.

Eventually, other people may fill in the gaps. Even now, I think of things I wish I had asked my dad about. But I didn't, and that's okay. The main thing I want people to know is not to wait too long.

I also would encourage people to take pictures every day. Don't wait for those special moments. I took as many pictures of my

parents with my grandchildren as I could. I want them to remember my mom and dad.

I am creating memories one picture a day. There is a story behind every one of them. We may not know the significance of those photos now, but they will be very significant in the future.

About Jodi

Jodi Bondy used photographs to share precious time with her father, to find out from him the stories behind the photos, and to allow him to revisit wonderful moments in his life before he died. Together they created a rich legacy to pass down to her children and grandchildren. She is also a personal photo organizer and owner of Hoosier Photo Organizer.

Lessons from a Photo Therapist
by Judy Weiser

Viewing pictures and telling stories about them is emotionally healthy. It gives us a sense of who we are, where we came from, what has happened in the past that has put us on this path, and gives us a way to do some imagining about where we might be going. Photos point the way to where we might be going even though we don't realize it yet.

Photos tell our stories without words. We assume that everyone can read the language, but, of course, they can't. Photos begin the stories through their contents, their meanings, and the feelings embedded in them. It is the people who respond to the photos who create the stories and the meanings.

It's never too soon to share the stories of your family photos with the people around you. Tell the stories about the photos before those memories are lost. You tell the stories and people respond, and you tell them more. It becomes a dialogue. The person feels included because you're telling them his or her story. If it's your children, you're taking the time to tell them the story of your family, where your family came from, what difference your family has made throughout the years.

A photo that looks "ordinary" to us may trigger memories in someone else. Deep feelings emerge from their subconscious, and they go on a journey inside themselves back to the time the photo was taken.

The photo doesn't tell its secret until someone asks it questions. When someone shows you their photos, they are letting you into their lives.

We all assume that when we show someone a photo, that person will see what we see. We will see the same subject of the

photo: a dog, car, sunset. We will see the same details. We will not agree on what the photo is about.

Two people look at a photo. They may get different meanings, different stories, different feelings based on what they have brought to that moment—the unconscious filters that they use to make sense of what they are looking at. A mountain scene might be peaceful to one person. To someone who has survived an avalanche, it may bring up horror stories.

> Two people look at a photo. They may get different meanings, different stories, different feelings based on what they have brought to that moment—the unconscious filters that they use to make sense of what they are looking at. A mountain scene might be peaceful to one person. To someone who has survived an avalanche, it may bring up horror stories.

The body has memories associated with every moment that is remembered. If you're looking at a photo from many years ago, it will still trigger smells and feelings; you'll hear music. You'll perceive the whole scene that was happening, along with all the feelings and sensory data that was going on at the time.

As you look through your photos, realize that the feelings you are feeling are coming from inside you, which means they've always been inside you. It's simply that the photo has given you the opportunity to know that they are there.

A woman showed me a photo from the 1940s. In it, a group of siblings are lined up and a preteen girl is trying to get into the picture. She's behind them trying to get in between them. They're

close together, arms around each other's shoulders. They'd have to step apart to let her in. They did not do that. The woman said, "I think this is why I like to do public lectures and appear in public. I was the 'barely seen' child. When I came along, there was a whole bunch of other siblings already, and nobody really knew I was there. This picture is a perfect example of me trying to break through all that and be seen." To the rest of us, it's nothing more than a picture of people in a line.

<div align="center">***</div>

A photo doesn't hold the meaning. A person looks at it and projects the story onto it based on the feelings and memories and thoughts that it evokes for them.

I have a photo of a young child sitting on a chair looking sort of lonely or sad. I took it because I thought it was a cute picture— little child, big chair. A friend of mine saw it and got very, very still. It took her back to her childhood. She was a cute child and her mother took her to a studio to have her picture taken. It was the kind of studio that sold photos of little kids making funny faces to companies that made calendars. Her mother wasn't allowed in the room for the photo shoot. The photographer got those faces by giving the children a toy and taking it away so that they would cry. Or he would stick them with pins where it wouldn't be seen. The mother never knew of the abuse. My friend was too young to tell her. She never liked to have her picture taken, and she didn't know why, on a conscious level, until she saw that photo of the child.

<div align="center">***</div>

I have a photo that was taken when I was four years old. I've always liked it. I had on a cowboy suit, hands on my hips, looking defiantly at the photographer. It didn't make the family album.

My mother didn't like it. It was the stubborn me, the independent, in-your-face child that drove her crazy. She wanted me to be a proper young lady. In the photo that went into the album, I was curtsying in a pink satin shirt. That's the image my mother wanted.

One of those significant "0" birthdays, my husband took me on a boat trip to a waterfall. It was a beautiful day. My husband took a picture of me standing on the deck of the boat looking at the waterfall. When I saw the photo, it triggered something in me. I thought, "Oh, yeah, I made it. This is the me I wanted to be."

I went back to the picture of me in the cowboy suit and saw the same pose, hands on hips. Straw hat tilted the same way. Next to each other, they're identical. I saw that the child had turned into the adult that I am, that no matter what happened in between, the child that I was is very much the same.

Had I not kept that photo, had it been lost or burned in a fire or my mother had thrown it out, I would never have understood the feeling I had upon seeing my birthday picture.

OLD PHOTOS WITHOUT THE STORIES, HAVE VERY LITTLE MEANING

When I moved to Canada, I found a bunch of old photos in the attic of the home I moved into. I had no idea who these people were. The people were on a ship and had on old European, ruffled clothing. Someone had kept these photos and treasured them. Through the photos, they explained who they are, where they came from, what the family had survived over time, how that family came to

be, why that family is the way that it is. They are that family's story. The photos by themselves are not the story—you need a storyteller.

Throughout my life, people took pictures. The pictures got stuffed into albums. The album is the view of your family through the eyes and mind and feelings of the person who makes the album. You are looking at your family, perhaps not as it actually was, but as it was viewed by the creator of the album.

I was an only child growing up with a nice middle-class Jewish family. My mother and I would go through the family album. I'd notice that a particular person was no longer in the album, and Mother would tell me that was because he died. There were pictures of my mother's three brothers. Two of them were twins. Around the time they were twenty years old, there were no more pictures of one of the twins, Sam. I never ask why. I assumed he died or moved to another continent or something.

One day when I was teenager, I came home from school, and my mother said that I had to drive her to Sam's house. I was stunned. She was horrified that I had thought Sam had died and asked why I would think that. "You never talk about him; there are no pictures in the family album after he was twenty."

My mother thought I knew. The family was very strict Jewish, and Sam had met and married a woman who wasn't Jewish. "We gave him a funeral which is what Orthodox Jewish people did when somebody married outside the faith in those days. They are no longer a living person. They are not seen again, they are not talked about again, and their name is not mentioned again."

But my mother was a good woman and she needed to tell Sam that his twin brother died.

About Judy

Judy Weiser is a psychologist, art therapist, consultant, trainer, university adjunct faculty, international lecturer, and author—and one of the earliest pioneers of PhotoTherapy, Therapeutic Photography, Photo-Art-Therapy, VideoTherapy, and other related techniques. Founder and Director of the PhotoTherapy Centre in Vancouver, Canada, she is considered the world authority on the emotional significance of personal photographs.

Connecting with the Dad I Never Knew
by Marci Brennan

My father left my mother and me when I was about two years old, so I never really knew him. I was raised by two stepfathers. My mother was an only child, so there were no aunts, uncles, or cousins. But my mother's parents were a big part of my life.

My first stepfather, Tom, was the father of my three sisters. I knew from a young age that Tom wasn't my father because we didn't look alike, and my sisters looked a lot like him. When I was about four or five, Tom legally adopted me, and my name changed. Neither Tom nor my mother ever discussed it with me. I had been Marci Ketchem, then all of a sudden, I was Marci Brennen.

My mother also never discussed my father. It was verboten. I didn't dare bring it up. But my maternal grandparents really liked my dad. I'd do something, and they'd tell me that my dad would do it also and that I take after him a lot. My dad was an avid reader, and when I went to visit them, first thing I would do is pick up magazines and leaf through them. They'd laugh and say in Italian to each other, "See? She's just like her dad." I'd ask them to stop: "I am not. I'm my own person."

My grandparents loved my father and hated my stepfather. But they had to treat him okay because he was the father of their three other grandchildren, my half-sisters. My grandparents always kept in touch with my father on the sly. They'd hear from him when he was in town and maybe have lunch with him. They'd tell him how I was doing. He had never paid child support, and when I was adopted, he couldn't legally contact me.

In my forties, I started sleuthing on the internet and tracked down one of my aunts, my father's brother's wife. Her name is Sheryl, and she was happy that I had found her, especially since

they were in the process of selling the home my father and his siblings grew up in. She wanted me to see it before it was sold.

The house was a 1920s Colonial-style mansion. There were rooms full of photographs! My poor aunt could have used a photo organizer, had she known of their existence. I found some photos of my father.

Growing up, I knew something was off, but I didn't know what it was exactly. When I got these photographs, I saw who my dad was as a young man. I was surprised and moved. I thought, "He's really cute!" He had this sort of surfer boy, Beach Boys thing going on. My mom was quite beautiful, and I could see why they were attracted to each other. I could see myself in him in these photos. There was definitely a resemblance, especially in our profiles.

A couple years later, my husband Chris and I went out to the West Coast for a friend's wedding. While there, we drove down to California where my father's twin sisters live. I got to meet them and my cousins for the first time. Even though I knew nothing about them, they always knew about me. They called me "Marci mystery person." It was very emotional in a nice kind of way. We're Facebook friends now. They don't look anything like me, but my father's brother's kids do.

My aunt had done some family genealogy, and she had photographs of relatives going back to the 1800s. There was a picture of my great-grandmother, who was gorgeous. She looks just like my cousin Laura.

I found out about my father when I met my aunt on the East Coast and my aunt and cousins on the West Coast. They gave me the whole story of his marriages and his wives. Through the stories behind the photos, I learned all about his life's losses and successes.

It gave me a sense of completeness and verified what I had long suspected. I saw where my nose came from! I loved sailing, and my father was an avid sailor. He was a tennis player also. I don't play well, but I try, and I love ball sports. It was interesting to go down the list. I saw the ways in which I take after my mother and the ways I take after my father.

I can't stress enough the importance of preserving images. They're a physical lifeline to our past. We need to know the story of where we came from. If I didn't have those photos of my father, I'd still feel sort of unfinished as a grown-up. Having these pictures is a tangible connection that can't be felt any other way.

> I can't stress enough the importance of preserving images. They're a physical lifeline to our past. We need to know the story of where we came from. If I didn't have those photos of my father, I'd still feel sort of unfinished as a grown-up. Having these pictures is a tangible connection that can't be felt any other way.

It's your personal history come to life. I was a photo researcher at the Bettman Archives, which has eighteen million photographs. I was so lucky that I was able to do that as a career. I actually went through physical photographs and old glass plate negatives, and I saw history come alive.

Discovering the similarities between my dad and me confirmed what I knew subconsciously. I wouldn't trade those pictures for anything. They're precious. They're more than just pictures. They put the pieces together for me: "Oh, this is why I am the way I am." It's unfortunate that I wasn't able to connect with my dad before he died.

One of my aunts noticed that I walk like my father, and she told me he was always cracking his knuckles as I do. She was excited, "You're so much like Dick!" I'm the product of a lot of things, but I'm also myself. All she could see was my father because she loved him so much.

Finding my family and the photos had a far-ranging effect—on all those relatives from coast to coast, certainly on me, and on my husband who joined me in completing that item on my bucket list.

About Marci

Marci is a personal photo organizer and the owner of, Past Present Pix. She lives in Queens, New York and had no contact with her father from the time she was two years old. She was adopted by her stepfather when she was four. It wasn't until she was in her forties that she met relatives on her father's side and saw photographs of her father and his family and ancestors.

A High School Graduation Gift
by Andrea Sims

Judy wanted to celebrate her daughter, Taylor, who was a senior in high school. Taylor felt that she hadn't found her place to shine in the large high school, and Judy wanted to celebrate the activities outside of school that Taylor had excelled in throughout her childhood and teen years.

At the beginning of the school year, seniors in Taylor's school place recognition ads in the yearbook, and Judy asked me to design Taylor's. She and her husband purchased a small corner space and wrote a special message. We added a photo on a background color that complemented it. Taylor's ad was an eye-catcher.

By January and February, there were activities during which memorabilia was shared. At the senior breakfast, there was a slideshow of the seniors' baby pictures. Then there was signing day, when athletes are recognized for their scholarships. The school had started recognizing art students who had received scholarships, and that included Taylor's to New York University. Judy and I had fun setting up a personalized table display for Taylor, and we used some of those items for the graduation party held two months later.

Next was Taylor's graduation announcement. The front announced that she would be going to NYU; the back was a party invitation. We designed little pennants with special messages for Taylor. Judy had a beautiful family portrait, and we put messages from family members around its edges. It was a special and very personal gift for Taylor that she could take to college without it being too large or embarrassing for a brand-new student.

Judy had several of Taylor's school portraits taken throughout the years. We blew them up to 8 x 10 and made "Taylor through the years" signs to decorate the front yard on the day of her graduation party. Judy and I were very excited about them, but Taylor—not so much. As

any teenager would be, she was embarrassed, and we had to put them in the back yard. The party guests could see them through a window.

Also, for the party, I helped with table vases that had different pictures in holders. One of the things that Judy and her husband really appreciated was the consistency. Because I had helped at each stage of their celebration of Taylor, there was a theme that tied it all together. They felt it was a time in Taylor's life that was a culmination of years of hard work. All the different pieces of their celebrations were a look back and a recognition, while they would also be treasured keepsakes in the future.

Taylor's initial reaction to the "fuss" was embarrassment, but as Judy and I designed the announcements, the Signing Day display, the photo pennants, centerpieces, portrait yard signs, and the slideshow, Taylor's pride grew. In the end, Taylor was excited to share her accomplishments with family and friends.

Speaking of the yard signs, I used that idea with a client who was giving her mother a seventieth birthday party. The daughter came to me for a slideshow of photos of her mother through the years with approximately fifty-some photos. Then, we met with her mother and went through her photos. I got chills as we sorted them. There was her whole life in front of us. She said, "Oh, I've had such a wonderful life." She surely did. And here she was, having the opportunity to look over her life and reflect on it. By the time we finished, we had more than 200 photos.

> There was her whole life in front of us. She said, "Oh, I've had such a wonderful life." She surely did. And here she was, having the opportunity to look over her life and reflect on it.

So her mother knew about the slideshow. She didn't know about the portrait yard signs. On the day of her party, the signs greeted her, and she was in tears before she reached the front door. Maybe it takes a little bit of age before we can appreciate childhood portraits.

Everyone loved the signs, and the mother felt special. She was excited to be celebrating her age. She was honored by all the guests that came. All her grandchildren had traveled from other states. It was a special moment for them.

I think the tendency is to put photos in chronological order, as we did for the woman's seventieth birthday, for a slideshow, or whatever pictorial form you want to use to celebrate someone. How about reflecting on a person's life through themes instead? I'll use my daughter as an example. She's only ten now, but let's say I'm putting together a graduation book or slideshow. There are three themes that stand out, about who she is now and who she's becoming. One theme would be "dress-up". I have photos of her as a preschooler with the funny things they put on; then as she gets older, she's dressed up for the daddy daughter dance. I look forward to having photos of those dress-up occasions at high school dances and programs.

The next theme would be "Play Ball". She's athletic and plays ball, and then there are the hundreds of times she watched her brother play.

The third theme would be about animals. My daughter is a total animal lover: live animals, stuffed animals—it doesn't matter. I have tons of pictures of her at the big zoo or at the petting zoo. Upstairs right now, she has a huge condo that she built for her stuffed animal doggy. She also has a collection of animal artwork that she has done.

Either way, chronologically or thematically, photos are a special and memorable way to celebrate a life.

About Andrea

Andrea is the owner of Your Story. Share It! Among the services she provides is helping clients celebrate life's milestones with photobooks, slideshows, invitations, and party decor.

Value of Adoption Lifebook
by Philip Griffith

I describe a Lifebook as saying, "I'm real." When children are babies or toddlers, there's all this stuff going on, but they don't remember any of it. When they see pictures of places and people and particularly themselves, it makes all the stories you tell them real.

It's like when you are looking at your own family photo album, and you see yourself as a baby, see yourself being brought home, and you're hearing all the stories your parents tell you about what happened at the birth and what happened when you came home.

I, as the adoptive parent of two boys, don't have those stories for them. What I might have, depending on the situation, are photos. Or, for us, we had hospital letterhead that had details about the birth and who the attending doctor was and the nurse. We have something that is physical that demonstrates that, just like everyone else, you were born. A lot of adopted kids say it doesn't seem real to them. Lifebook makes it real. The pictures make those things real.

I was like everyone else. When I first heard about a Lifebook, I thought right away, "I need to do this. I want to do this for my child." Then you get into it, and it's hard. You have to face the realities of the loss that the child is going through. You remember all the emotions and the journey. You have to put that all aside to be able to tell a child's story. Sometimes our children have gone through some really hard times.

As you make the Lifebook, you have to acknowledge those hard times and figure out how you want to talk about them in a way that won't be crushing to a child, but in a way that is not hiding it from them. It all depends on the age of the child. Later in life, when they are ready for the whole truth, you don't want them to feel you were hiding anything.

International adoption is especially difficult. In China, you have no information prior to the abandonment. You may not even know the birth date. You have other countries where orphanages were just horrible, and the child was left alone. Those are hard things. I realized that making a Lifebook is as much for me, the adoptive parent, as for my child. I needed to become comfortable with telling my child's story truthfully yet not painfully for him.

At this stage of my sons' lives, I have to get the Lifebooks out and sit the boys down and say, "We're going to do this." They are starting to ask questions and want to get beyond the book that was written for them when they were three, four, and five years old. Those books functioned well when they were children.

I'm encouraged by the questions. It means they are thinking about things. The Lifebooks are still a place to go to start asking questions and a place to go to open the conversation. It gives my sons and me a point of reference, something that we can look at together and be on the same side—as opposed to feeling like we're on opposite sides, fighting over something.

I don't know if I'm expressing that well. I'm thinking of when your child starts questioning: "Why was I adopted?" You try to figure out if he is asking "*Why* was I adopted?" or "Why was *I* adopted?" What's the real question there?

It doesn't end with the Lifebook. That's merely the start of the process. We've continued to make books about our family and about each boy. We're saying: "Yes, you were born, and now you're growing up, and here's your life. Just like everyone else, you are part of a family, you've been to these events, and we've celebrated these birthdays. Look at all the things we've done and the places we've been to." Those are the kinds of things that give children a sense of identity and stability. That's really what the Lifebook is supposed to be—a touchstone. We all need to see ourselves within the context of the family and the community.

I was at a teachers' conference and felt it was important to tell their teachers that the boys are adopted. They are teenagers. This is the time when adoption issues come up. I wanted their teachers to know in case something comes up in class. It turned out that one of the teachers was adopted, and she said there are several other kids in the class who are adopted. She also said that it has come up in class, and both boys have been very open about it. That was gratifying for me. I talked with them and used the Lifebook to

> My son Carlos said, "A Lifebook helps me to keep my past and to know how lucky my future is." Christopher said, "The Lifebook gives me a sense of my heritage and culture. It answers questions that I have about my birth parents."

help them rehearse their story and understand where they are from and the adoption process they went through so that they would feel comfortable talking to other people about it.

My son Carlos said, "A Lifebook helps me to keep my past and to know how lucky my future is." Christopher said, "The Lifebook gives me a sense of my heritage and culture. It answers questions that I have about my birth parents."

About Philip

Philip owns PSG Photo Solutions ("Let Us Help You Tell Your Story"). Designing a Lifebook for his adopted sons led him into using photographs and the stories they tell to create Lifebooks for other families.

Helping Patients with Memory Loss
by Kathy Rogers

I make Memory Care books more for the families of dementia patients. The patients themselves may not have the cognitive capabilities or the eyesight to enjoy the books. We prefer to get the book done while the patients can understand and appreciate it, but that doesn't always happen, and even when it does, it doesn't last long.

My clients are usually the adult children of dementia patients who want help in capturing fleeting memories. A Memory Care book isn't a "This Is Your Life." It's a selection of happy moments.

Memory Care books help with transitions. When it's time to enter a care facility or when a patient transfers to a stepped-up level of care in a continuing care or retirement community, the book can be something new to focus on that helps soothe and redirect him or her.

The purpose of the book is to focus on the good times. We begin by choosing the right photos. We want photos of the person smiling, because happy faces evoke happy memories. We focus on the positive, not on something that may make the patient sad. For instance, I was doing a gardening page for a friend's mother who is a master gardener. It's her passion. I focused on her gardening work at her retirement community. Had I included photos of the gardens of her home, it may have made her sad that she no longer lived there.

It helps people to start choosing photos when I tell them I want photos of important and happy memories and ones that show the person in action. We just want a few memories. If it's difficult to decide what photos to include, we can do multiple books. But for right now, for this book, we need to be selective.

After people see how easy the first book is and how well received, they usually want to do another book or a book for another loved one when the time comes.

I edit and advise. Naturally, all of the photos are important to the families. I point out ones that tell a really good story and ones that are not dark or blurry. No matter how special the moment of the photo is, it needs to be one that will be easy for the patient to see. That's also why it's best to have one or two pictures per page and to use a large font for the captions. In addition to memory issues, some older people may have trouble seeing. Eye fatigue is a real problem. So in addition to the extra-large text, the book has simple backgrounds.

One time I was working with a woman in her seventies who was doing a book for her brother. She appreciated my editing. She said, "I keep going into the memories, and I need somebody to pull me back and keep me focused on what this book is about." I used to work in health education, and I bring those same skills and compassion to helping people stay focused on the task at hand and make confident decisions. I have also made many books for my own family.

One of the first books I did was for my father-in-law, and I learned a lot from doing it. One thing that was totally unexpected is that the book helped visitors make conversation with him. Some family members didn't know what to say when they visited. The photos in the book always got them talking.

My father-in-law had Lewy Body syndrome. You could tell there were things going on in his mind, but he was unable to speak. Photos and family stories had always been important to him. I did a book of my husband's childhood. Once he had the book, he could smile, point to a picture, and my brother-in-law who lived

right near the care facility would repeat the story to him. They could interact that way.

It was at that time that I realized I had too many photos on the page. I did another book with more recent pictures of the grandchildren and some of things they liked to do. It's nice to have a couple of books to choose from.

The books were helpful in another unexpected way also. The hospice volunteers loved having the books with the photos and captions. The volunteers who didn't know him or had only been in a couple times could have a more meaningful visit. The book allowed them to know him as a person.

> The books were helpful in another unexpected way also. The hospice volunteers loved having the books with the photos and captions. The volunteers who didn't know him or had only been in a couple times could have a more meaningful visit. The book allowed them to know him as a person.

We found that also with my husband's aunt, his father's sister, when we were moving her into a memory care facility in Brooklyn. By then, she was elderly and Alzheimer's had really taken hold, so that sometimes she was belligerent and sometimes she was sweet. She had been a professional flutist with the Metropolitan Opera and toured the world with them in the 1960s, not something that a lot of women got to do. The staff was impressed. I could see, as we were getting her settled in, that they were more interested in her life and who she was than they were with her fixation on paper clips.

It's amazing and heart-warming that even just a few photographs can have such an effect on the lives of patients and on the lives of all those they touch.

About Kathy

Kathy Rogers, owner of Baltimore Photo Solutions, creates Memory Care books that contain photographs and captions that may retrieve some lost memories for dementia patients, that capture fleeting memories for their loved ones, and that introduce caretakers to people who had rich, interesting lives before they became patients.

Your Story Started Before You
by Rachel LaCour Niesen

When my grandfather died, he left behind photographs that few, if any, members of my family had ever seen. I wanted to use the photos to celebrate my grandfather's life, and I wanted to involve the family. Social media is a fun and collaborative platform, so I posted a few photos of my grandfather on an Instagram account, "Save Family Photos." I asked family members if the photos brought back memories. That opened a floodgate!

My grandmother, my mother, other relatives, all had stories. With the photos, I not only honored my grandfather, I also learned more about him and about the rest of the family. The photos created a whole new level of understanding among the family about our shared history. The atmosphere of healing and bonding would not have happened otherwise.

I invited a few close friends to send me their family photos that I featured on the Instagram account. Each photo was captioned with what was, essentially, a short story about the person or people in the photos—about the moment in time captured and how it related to that family's history.

Very soon, more people joined us. They also wanted to celebrate the power of family photos, especially the vintage ones that have been hidden away in shoeboxes. Those are the most cherished ones. They usually are one of a kind. The Instagram account became a virtual campfire. People would stop by, pull up a seat, and tell stories through the photos that had been stashed away in attics and basements.

The photos remind us that we are more alike than we are different and that families want pretty much the same thing for themselves and for one another. I see common themes of families

together, loving each other, celebrating small moments that historians would never bother to record because they're not global events. But for families, they're everything.

Candid photos, or even somewhat accidental ones, show our humanity. Maybe it's a portrait that went wrong—one child crying or pushing the other one. Maybe it's an in-the-moment snapshot of a mom in the kitchen. Those quick snapshots are of the "in-between" moments; they capture our authentic selves—universal images that we all can relate to and smile at.

> Candid photos, or even somewhat accidental ones, show our humanity. Maybe it's a portrait that went wrong—one child crying or pushing the other one. Maybe it's an in-the-moment snapshot of a mom in the kitchen. Those quick snapshots are of the "in-between" moments; they capture our authentic selves—universal images that we all can relate to and smile at.

I never expected when I posted those first photos of my grandfather that a single photo can be a powerful tool for recognizing our shared humanity.

The Instagram community quickly grew to almost 32,000 followers. I feel honored that people have given me these intimate moments from their family life in a very public way that I think encourages everyone to recognize the importance of their photos.

The Instagram project and the Save Family Photos community demonstrates that you can start with a handful of photos. Ask your family what they know about them. More family will get involved. They'll want to help you organize your photos, and they will pick out the ones most memorable, or most intriguing, to them.

To start gathering the memories behind the photos, allow yourself to select them in an intuitive, reactive way. Spread the photos out on a big table. It will be the most marvelous patchwork quilt of scenes and faces. Just scan them for a while, and your eyes will begin to settle on the photos with the most powerful content. There may be an aspect of the subconscious going on here. You'll see that the photos that resonate with us emerge rather quickly, as long as we don't get too analytical or focus on unimportant things. It doesn't matter if the photo is out of focus or the color has faded or the arrangement is off-kilter. Only the content matters when it comes to treasured memories. Sarah's story encapsulates the power of photos and Save Family Photos as a community.

Sarah's father gave her some of those old photo-booth pictures of her grandmother. Her grandmother had worked at a department store, so, on her break, she'd go to the photo booth and have her picture taken. They are very sweet snapshots of a young woman.

She was so touched by seeing her grandmother as a young woman that she took the photos to her grandmother, and they had the best conversation ever. Her grandmother told Sarah what it was like being a young woman in that era, what it was like working at the department store, what her hopes and dreams were, and how those had changed over the years. The photos were a catalyst for a deep, deep conversation that will be cherished by both of them forever.

Her grandmother was in the hospital at the time. Sarah doesn't know if her grandmother would have opened up as much as she did except for the photos, which evoked such fond memories for her grandmother. Ask relatives, "What do you remember? What was happening in this picture? Is this you? Is this another relative? Were you on vacation?" Any question about the photo opens up a

much deeper conversation about what family means, how we care for each other, how we're all growing and changing.

Save Family Photos seems to be giving people permission to start with one or two photos. Trying to tackle those boxes with years and years of photos can be paralyzing. I feel that I can be a catalyst for people to dig out these photos from wherever they've been hiding, to acknowledge their value, and to take that next step and use them to conjure up memories and bring out the family history stories.

About Rachel

In an inspiring correlation of the vintage and the contemporary, Rachel has taken advantage of the opportunities afforded by our omnipresent social media to found Save Family Photos on Instagram, an online community whose mission is to save family stories one photo at a time.

Cathi's Pics

Websites

Cathi Nelson
www.CathiNelson.com

Association of Personal Photo Organizers
www.appo.org

Photo Organizers Academy - Online Classes
www.photoorganizers.academy

Photo Safety Tips & Help
www.saveyourphotos.org

Social Media

Facebook
https://www.facebook.com/thephotoorganizers/
https://www.facebook.com/cathinelsonspeaks/

Pinterest
https://www.pinterest.com/photoorganizers/

Instagram
https://www.instagram.com/photoorganizers/

CHAPTER ONE

Forms

Download our simple-to-use checklists to make your organizing
job easier. www.cathinelson.com

Family History Help

Ten Apps for Family History
www.familysearch.org/blog/en/10-cool-apps-family-history/

Dead Fred
http://www.deadfred.com/

Family Search
https://www.familysearch.org/

CHAPTER TWO

Photo Organizing Supplies

Archival Methods
https://www.archivalmethods.com/

Adhesive Removal
https://www.un-du.com/

Photo Restoration

Adobe Photoshop
https://www.adobe.com/

Perfectly Clear
http://www.athentech.com/assets/perfectlyclear/

Personal Photo Organizer
www.appo.org

Vivid Pix
https://www.vivid-pix.com/

Industry Standards

The Image Permanence Institute
https://www.imagepermanenceinstitute.org/about/about-ipi

Library of Congress
http://digitalpreservation.gov/personalarchiving/

Online Classes

Creative Live
https://www.creativelive.com/

Lynda
https://www.lynda.com/

My Workflow Studio
https://www.myworkflowstudio.com/

Digital Photo Organizing Pro
http://theswedishorganizer.com/dpopro/

CHAPTER THREE

Forms

Cathi Nelson Website
www.CathiNelson.com

Digital Preservation and Outreach
http://digitalpreservation.gov/education/index.html

Photographer Registry
http://www.ppa.com/about/content.cfm?ItemNumber=1753

Flatbed Scanners

Epson Scanner V600
https://epson.com/For-Home/Scanners/Photo-Scanners/
Epson-Perfection-V600-Photo-Scanner/Canon

CanoScan 9000F Mark II https://www.usa.canon.com/internet/portal/us/home/products/

Mobile Scanner

Flip Pal
https://flip-pal.com/

Rent a Scanner

EZ Photo Scan
https://ezphotoscan.com/

Personal Photo Organizer
Association of Personal Photo Organizers
www.appo.org

Scanning Apps

Photomyne
https://www.photomyne.com/

Scanning Software

Bring your old scanner back to life
VueScan: https://www.hamrick.com/

Lightbox App

Light Box—Illuminator Viewer
https://itunes.apple.com/us/app/light-box-illuminator-viewer/

Recommended Book

The DAM Book Guide to Digitizing Your Photos with Your Camera and Lightroom by Peter Krogh
http://thedambook.com/dyp/

Scanning Companies

Fotobridge
http://www.fotobridge.com/

Everpresent
https://everpresent.com/

Charter Oak Scanning
https://charteroakscanning.com/

Digital Memory Media
https://dmmem.com/

Personal Photo Organizer
Association of Personal Photo Organizers
www.appo.org

Roots Family History
https://rootsfamilyhistory.com/

Archival Boxes and Sleeves

Archival Methods
https://www.archivalmethods.com/

Children's Artwork

Keepy Me
https://keepy.me/

Table Top Lightbox

Shot Box
https://shotbox.me/

CHAPTER FOUR

Cloud Backup

Back Blaze
https://www.backblaze.com/

Duplicate Finders

Duplicate Cleaner (PC)
http://www.duplicatecleaner.com/

PhotoSweeper (MAC)
https://itunes.apple.com/us/app/photosweeper/id463362050?
mt=12

Permanent Cloud Storage

Forever
https://www.forever.com/

Desktop Photo Organizing Software

Adobe Lightroom
http://www.adobe.com/products/photoshop-lightroom.html

Mylio
http://mylio.com/

Historian (*PC only*)
https://www.forever.com/historian

Online Photo Organizing

Flickr
https://www.flickr.com/

Forever
https://www.forever.com/

Smug Mug
https://www.smugmug.com/

CHAPTER FIVE

Home Movie Conversion

Pro 8mm
https://www.pro8mm.com/

Everpresent
https://everpresent.com/

Forever
https://www.forever.com/

Fotobridge
http://www.fotobridge.com/

Movie Editing

Apple iMovie
https://www.apple.com/imovie/

Final Cut Pro
https://www.apple.com/final-cut-pro/

Windows MovieMaker
http://www.windows-movie-maker.org/

CHAPTER SIX

Family Photo Archive

Smug Mug
https://www.smugmug.com/

Forever
https://www.forever.com/

Ancestry
https://www.ancestry.com/

Zenfolio
https://en.zenfolio.com/product/features

Online Book

The DAM Book
http://thedambook.com/the-dam-book/

CHAPTER SEVEN

Digital Photobooks

Picaboo
https://www.picaboo.com/

Blurb
http://www.blurb.com/

Mpix
https://www.mpix.com/

Custom Photobook Design

Books of Life
https://www.yourbooksoflife.com/

Personal Photo Organizer

Association of Personal Photo Organizers
www.appo.org

Video Montages

Pro Show
http://www.photodex.com/proshow

Animoto
https://animoto.com/

SmileBox
http://www.smilebox.com/

Custom Framing

Framebridge
https://www.framebridge.com/

Pictli
https://www.pictli.com/#/

Traditional Photo Albums

Creative Memories
https://www.creativememories.com/

Kolo
https://www.kolo.com/

Digital Scrapbooking Software

Artisan
https://www.forever.com/artisan

Project Life
https://beckyhiggins.com/

Heritage Makers
https://www.heritagemakers.com/

Digital Photo Frames

Nix Play

https://www.nixplay.com/

Help with Digital, Printed Photo Organizing, Gifts, Photobooks, Legacy Videos

Association of Personal Photo Organizers

www.appo.org

CHAPTER EIGHT

Save Family Photos

https://www.savefamilyphotos.com/

Cathi Nelson

www.CathiNelson.com

Endnotes

1. James Wallman, *Stuffocation: Memories Live Longer Than Things* (Spiegel & Grau, 2015).
2. Charles Duhigg, *The Power of Habit: Why We Do What We Do in Life and Business* (Random House Trade Paperbacks, 2014).
3. Where to Gather: Finding Photos of Your Ancestors in Unexpected Places, 2016. www.organizingphotos.net/gather-ancestors-photos.
4. PhotoTree, Gary Clark, Identifying and Dating 19th Century Photographs, http://www.phototree.com/identify.htm.
5. Allison Gilbert, "Nostalgia," *Oprah Magazine* (November, 2016): 91–93.
6. Peter Krogh, *The DAM Book Guide to Digitizing Your Photos with Your Camera and Lightroom. DAM Book Guides*, http://thedambook.com/.
7. Cora Foley (SmoothPhotoScanning.com) interview by Caroline Gunther, December, 2016, http://www.organizingphotos.net/store-photo-negatives/.

8. Jackie Jade (attorney with Jade & Oak), interview by Caroline Gunther, Can I Scan that Photo–Legally? Understanding Copyright and Fair Use, September 20, 2016.

9. Brad Feld, "My Travels in Digital Organizing Hell," available at https://www.feld.com/archives/2015/12/progress-digital-photo-organizing-hell.html.

10. Mike Yost, "The Most Photographed Generation Will Have No Pictures in 10 Years," available at https://mikeyostphotography.wordpress.com/2015/01/31/the-most-photographed-generation-will-have-no-pictures-in-10-years/.

11. Caroline Guntur, Save Your Digital Photos First, http://www.saveyourphotos.org/save-photos-start-digital-photos/.

12. Foster Huntington, *The Burning House* (New York: Foster Huntington, 2012).

13. See http://thephotoorganizers.com/name-game-file-numbers/.

14. Peter Krogh, webinar, available at https://librisblog.photoshelter.com/metadata-best-practices-digital-asset-management-expert-peter-krogh-webinar/.

15. International Press Telecommunications Council, available at https://iptc.org/standards/photo-metadata/iptc-standard/.

16. Rhonda Vigeant, *Get Reel About Your Home Movie Legacy* (Valencia, CA: Rock Star Publishing, 2012).

17. Rhonda Vigeant, *Get Reel About Your Home Movie Legacy* (Valencia, CA: Rock Star Publishing, 2012) 79.

18. Bruce Feiler, "The Stories that Bind Us," The *New York Times*, March 15, 2013. Available at http://www.nytimes.com/2013/03/17/fashion/the-family-stories-that-bind-us-this-life.html?pagewanted=all&_r=0.

About the Author

Cathi Nelson, author of *Photo Organizing Made Easy,* is the founder of APPO (Association of Personal Photo Organizers), a membership organization dedicated to helping hundreds of entrepreneurs from around the globe build successful photo preservation and organizing businesses.

Considered a trailblazer in the photo organizing industry, she has been interviewed by *The New York Times, The Wall Street Journal, Chicago Tribune, The Atlantic,* and *Better Homes and Gardens,* and is a regular contributor to Houzz. She has presented at conferences including the National Association of Professional Organizers, the Association of Professional Declutterers and Organisers in

London, the Professional Organizers of Canada, and Tory Johnson's Spark and Hustle Boston.

Cathi holds a certificate in Women's Leadership from the Hartford Seminary, a Master's Degree in Liberal Studies from Wesleyan University, and a Bachelor's Degree in Communications from the University of Connecticut.

Cathi is available for speaking and consulting. Visit www.CathiNelson.com to learn more.

Hire a
Photo Organizer

"You can't tell your story and enjoy your memories with good intentions."

Organizing your memory collection may present a challenge or two. A lack of time or technology obstacles can derail the best of intentions. When you get stuck, consider working with a professional photo organizer.

Go to www.appo.org to find a photo organizer near you.

Become a
Photo Organizer

*"Turn your passion into profit while helping
others tell their story."*

You got this! You surprised yourself and enjoyed the process. You've got the flair, they've got the photos... we've got your back.

*Visit www.appo.org to learn about
certification, training and support and
turn your passion into a thriving business.*

Hire
Cathi Nelson

"We are more alike, my friends than we are unalike."—Maya Angelou

Photos and stories unite audiences and connect people because we are more alike than we are different. Cathi is a master storyteller and speaker who uses her love of photos and unique narratives to engage her audience and connect them to their stories.

Go to www.cathinelson.com to see a list of upcoming speaking events.

96502205R00109

Made in the USA
San Bernardino, CA
20 November 2018